WE, CHILE

*Personal Testimonies of the
Chilean Arpilleristas*

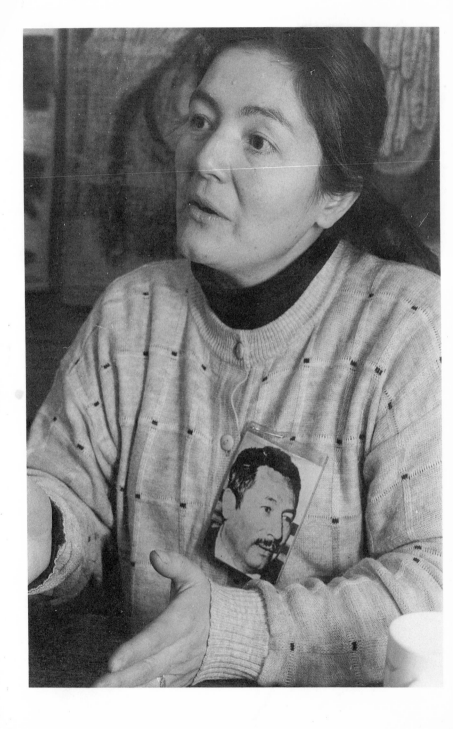

WE, CHILE

Personal Testimonies of the Chilean Arpilleristas

Edited by
Emma Sepúlveda

Translated by
Bridget Morgan

Azul Editions
MCMXCVI

Published by *Azul Editions*
7804 Sycamore Drive
Falls Church, VA 22042
USA

ISBN 1-885214-08-1
Library of Congress Catalog Number: 95-83885

Printed in the United States of America

First Edition
10 9 8 7 6 5 4 3 2 1

CONTENTS

ACKNOWLEDGMENTS

This book is the fruit of many years of investigations, journeys, visits, conversations, photographs, and filming. These histories are but a minimal representation of the pain and agony of many people who suffered the disappearance, torture, and death of their loved ones.

I began my work with the *arpilleristas* with the formation of their workshops in 1976. My first encounter was as a photographer; I accompanied my friend and colleague, Marjorie Agosín, to the first interviews. Since then, I've spent countless hours visiting the workshops and carrying *arpilleras* from Chile in order to promote workshop production as well as tape the women's testimonies for different projects in the United States. I can say with absolute certainty that this has been one of the most humane and satisfying projects in which I have participated during all my years of academic life.

In my adopted country I have received a great amount of assistance in the completion of this book. My colleagues Richard Curry, Diana T. Rebolledo, Joy Logan, and Guillermo Meza have been, directly and indirectly, continual sources of inspiration, advice, and illumination in all of my projects.

Now, after twenty-one years, I wish to dedicate this book to all the people who, in so many ways, helped to make this project a reality.

My first dedication is to the memory of the

arpilleristas who died during the past two decades still searching for an answer to the disappearances of their sons, husbands, brothers, and fathers. I also dedicate this work to the *arpilleristas* who continue fighting to find out the truth and see justice done, women who continue the daily struggle, with indefatigable strength, so that never again in Chile, nor in any other part of the world, will human rights again be violated.

I am grateful to the University of Nevada, Reno, for bestowing upon me the Thornton Peace Award for my work with the women of Chile.

My most sincere thanks to the people who helped me complete this project. Bridget "Tammy" Morgan, one of my best students during my career as university professor, worked without rest on the translation of the manuscript while also writing her doctoral dissertation *From Faust to Farándula: The Changing Role of the Musician in Spanish-American Literature* at the University of Michigan. Isabel Larraín, the Chilean poetess, helped with the painstaking task of recording the testimonies. I wish to also thank Dr. Thomas Writh for the pages that give this book the historical context and which guide the reader with a background of the political/historical reality of Chile during the last twenty-one years.

My profound gratitude also to Maya Miller, a pioneer in the struggle for social justice in the state of Nevada, for her contribution to the cause of Chilean women in 1988. Maya Miller is and always will be a great inspiration to all women who embark on the struggle for a better social and political future for the generations to come.

8

Special thanks to go Richard Schaaf of Azul Editions for his help in life in bringing about a written record of these voices and their testimonies.

And, finally, I dedicate this book with the most devoted gratitude to my companion throughout the years, John Mulligan, and to my son Jonathan, who have been my strength and inspiration during the most difficult moments of these last years. Thank you for allowing me to grow and share my life with so many causes, some of which were unpopular and impossible to win. Thank you for always waiting for me in international airports, ready with your loving embrace, when you knew I would be returning from Chile with photographs, documents, and *arpilleras* and there was the possibility that, perhaps, I might forever be detained on the far side of the mountains.

This book is another small homage to the memory of my mother, Angela Pulvirenti Salinas, because she died during the years of the dictatorship still giving thanks to life. It is also homage to Barbara Feltner who walked beside me, hand in hand, on the most difficult paths of my new life in the United States.

FOREWORD

Latin America in the 1990s is emerging from one of the darkest periods of its history. Reacting to real or perceived threats of revolution, military governments in Brazil, Argentina, Uruguay and Chile from the 1960s through the 1980s institutionalized state terror as a method of governance and turned arbitrary detention, torture, summary executions, and disappearances into routine occurences. Peaking in the 1980s, the Central American civil wars in El Salvador, Guatemala, and Nicaragua were marked by the use of death squads, peasant massacres, and scorched earth policies to defeat insurgents or topple governments. Both insurgents and governments in several other countries used these methods, albeit more selectively. As a result, the Salvadoran death squads, the Argentine "dirty war," and the Chilean DINA gained worldwide infamy, and Latin America as a whole developed a negative reputation — well deserved in many cases — as a region where international agreements such as the United Nations' Universal Declaration of Human Rights (1948) did not apply.

In reaction to these conditions, vigorous human rights movements have developed in several Latin American countries with the support international organizations and, in most cases, the Catholic Church. Women have been at the forefront of these movements. Their involvement often stemmed from the fate of family members and loved ones who became the victims of human rights

11

abuses. Commonly, women joined together for group solidarity and later developed various forms of protest ranging from letter writing campaigns to street demonstrations to adapting art and artisanry as means of denouncing human rights violations. Because of their early and bold involvement, women often spearheaded the formation of broad human rights movements that eventually encompassed numerous groups, each with a specific cause, organized under the umbrella of a national human rights committee. Such is the case in Chile, for example, where the women whose stories are told in this book formed the Asociación de Familiares de Detenidos Desaparecidos in 1974; owing in no small measure to the example they set, at the end of the Pinochet dictatorship in 1990 there were 52 separate human rights organizations with some 3,000 members. (1) These women, the arpilleristas, are not as well known outside their own country as some others, such as the Mothers of the Plaza de Mayo in Argentina or Rigoberta Menchú, recipient of the Nobel Peace Prize for her struggle for Guatemalan Indians. This book documents the arpilleristas' struggle against the Pinochet dictatorship and their contribution to the Latin American human rights movement.

September 11, 1973, was a watershed in Chilean history and in the lives of the women whose stories comprise this book. Destroying Chile's distinctive tradition of civilian, democratic government, the armed forces on that fateful Tuesday overthrew the government of Dr. Salvador Allende, elected just three years earlier on a platform of rapid social and economic change designed to move Chile

toward socialism. Allende, fondly referred to by his followers as "compañero presidente," openly identified with and derived his greatest support from Chile's workers, peasants, and shantytown dwellers, or pobladores. It was these segments of Chile's population, including the arpilleristas, who would suffer most under the ensuing sixteen and a half years of military rule.

The coup was the first step toward a long-term military dictatorship with the ambitious agenda of cleansing Chile of all leftist influence, dismantling the liberal democratic state, and recasting the country's economy. The most public drama of September 11 was the bombing of the seat of government, the historic Moneda palace in downtown Santiago, after President Allende refused military orders to surrender. Allende was killed in the attack. Simultaneously, under cover of a declared state of internal war and an around-the-clock curfew, the military launched a reign of terror against leftist activists, union leaders, and the poor using mass arrests, military sweeps of industrial zones and shantytowns (poblaciones), beatings, torture, and summary executions. During the coup and its immediate aftermath, the National Stadium and other large public spaces filled up with prisoners, the hospitals with wounded, and the morgues with bodies.

The weeks and months following the coup witnessed thousands of arrests and disappearances and the beginning of the dreary spectacle of family members' daily searches for lost relatives in police stations, military bases, hospitals, and morgues. The Agrupación de Familiares de

13

Detenidos Desaparecidos was founded in 1974, under the protection of the ecumenical Comité Pro Paz and later the Archbishopric of Santiago's Vicaría de la Solidaridad, to provide moral and legal support for these heretofore lonely searchers. In the same year, the military government further institutionalized repression by creating the Direccion de Inteligencia Nacional (DINA), which detained and interrogated at will, operated formal torture centers, and killed regime opponents it could not silence, including Allende's former ambassador to the Unites States, Orlando Letelier, who with his North American secretary Ronnie Moffitt, was killed in 1976 by a car bomb in Washington, D.C. Block-by-block searches of Santiago's poblaciones became routine, and residents of worker neighborhoods were sent to detention centers as hostages to the good behavior of family and friends made ever more desperate by government economic policies. Under international prodding, the regime periodically released political prisoners and gradually moved toward limited tolerance of mild dissent, but it never altered the essence of the terrorist state.

All of the women in this book lost husbands, children, or brothers in the repression following the coup. But like the rest of Chile's poor, they suffered a double repression: Along with state terror, they were also subjected to the brutal consequences of the military's restructuring of the Chilean economy, which was based on the neoliberal model of the Chicago School and Milton Friedman, approved by the International Monetary Fund, and largely financed by foreign private banks. The so-called

"Chicago boys" set out to reverse half a century's policies of economic nationalism by reducing tariffs, lifting price controls, devaluing the currency, selling off state industries, cutting govenment spending, and courting foreign investment. Through the application of this "shock" therapy, the Chilean economy was thoroughly transformed and integrated into the global market. After an initial contraction, the neoliberal model took hold and the economy experienced what was called a "miracle" of rapid growth between 1977 and 1981. A deep recession in 1982 forced some modifications, but the Chicago model remained largely intact throughout the life of the military government and its tenets have been scrupulously followed by the elected governments of Patricio Aylwin (1990-1994) and Eduardo Frei (1994-2000).

While the neoliberal model provided an unprecedented bonanza for many entrepreneurs, the poor paid the price of the Chicago boys' radical economic experiment. With labor unions disbanded or tightly controlled and political activity banned, they were voiceless and defenseless against policies that eroded what for many had already been a marginal existence. While the formerly controlled prices of foods and other necessities were freed, wages were frozen at very low levels. Real jobs for the working class evaporated as Chilean industries contracted or collapsed in the new milieu of international competition. Unemployment at least tripled while real wages fell by at least a third, and by some estimates by as much as 60 percent.

The impoverishment of the poor was not just an incidental spinoff or necessary consequence of Chile's economic reordering. A number of policies seemed designed to punish the poor for their support of the Allende government. Drastic cuts in spending for social welfare, for example, ensured that the needy would receive little or no government help when it was most needed. A make-work program called the Programa de Empleo Mínimo paid wages so low that they did not even begin to cover a bare subsistence. The Pinochet go go ernment government privatized large parts of the state's education, health, retirement and other services and transferred government privatized large parts of the state's education, health, retirement, and other services and transferred much of the remaining public service responsibilities to the municipalities. Then through an urban "reform" of greater Santiago, new municipalities were created lumping together neighborhoods on the basis of socioeconomic homogeneity, and thousands of pobladores were forcefully relocated to new slum districts whose impecunious local governments could provide almost nothing in services.

The poor responded to the political and economic warfare directed against them in various ways. As jobs dried up, workers and their families turned in desperation to hawking cheap goods such as razor blades or candy on the streets or on the city's buses. At least half a million Chileans crossed the Andes as illegal immigrants to Argentina in search of subsistence. Some became politicized and joined the armed underground resistance.

Many turned to grass roots organizing to pool their resources and talents for survival. Often aided by groups within the Catholic Church, pobladores set up soup kitchens, artisanry shops, food buyers' cooperatives, housing committees, and other forms of popular organization to meet their basic needs. A 1986 survey found 1,446 such organizations in greater Santiago. (2). Among these was the arpillera workshop founded by women members of the Asociación de Familiares de Detenidos-Desaparecidos.

The work of the arpilleristas did not end with the return of civilian government in 1990 because both the human rights and the economic struggle have continued to the present. Despite the labor of the Chilean Commission on Truth and Reconciliation (Rettig Commission), which documented 957 individuals (the real number is undoubtedly much higher) who disappeared after detention during the dictatorship, not a single family member has been successful in prosecuting the presumed perpetrators. (3). And although Chile's economy has continued to grow, the indices of poverty and "extreme poverty" are slow to contract in the poblaciones. Now the women face a new challenge as, with the return of civilian government, the curtailment of human rights abuses, and the general economic boom, the help and solidarity they formally received have dried up. Yet as long as the legacies of political and economic repression persist, the arpilleristas have unfinished work, and if they are able to sustain their collective effort, the products of their workshop will continue to narrate what Emma Sepúlveda calls

the "parallel history" of these courageous women and the Chilean poor in general.

— Dr. Thomas Writh
University of Nevada

NOTES

1. Patricio Orellana and Elizabeth Q. Hutchison, El movimiento de derechos humanos en Chile, 1983-1990 (Santiago, Centro de Estudios Políticos Latinoamericanos Simón Bolívar [CEPLA], 1991.
2. Luis Razeto, "Popular Organizations and the Economy of Solidarity," in Kenneth Aman and Cristián Parker, eds., Popular Culture in Chile: Resistance and Survival, tr. by Terry Cambias (Boulder: Westview Press, 1991), 82.
3. Chilean Human Rights Commission, Summary of the Truth and Reconciliation Commission Report (Santiago, 1992), 92.

INTRODUCTION

Violeta Morales reminds me of the working-class women who fought for Allende's government; Toya makes me wonder what my life might have been if I had remained in Chile, struggling against the dictatorship. But History and our histories took different paths.

That spring morning in September 1973 I was studying, as were many young women of my generation, at the University of Chile in Santiago. During my fifth year in the History program, a brief three months before graduation, my destiny and that of thousands of Chileans changed forever. I was among those who was neither detained nor tortured, and who left to spend the rest of their life in exile. But Violeta, Toya, and the rest of the women who appear in the following pages remained to defend their lives and the lives of others.

After more than twenty years, with the distance of time, I now recount the history of a group of Chilean women who have fought for years to defend human rights.

Although I emigrated from Chile when I was twenty-three, my camera and I have been inspired by numerous visits to my homeland. Whenever I returned to my country, I sensed things were slowly changing, that everyone was sinking into a hopeless frustration. No one could clearly envision a future for their children. Everyone felt that, increasingly, their basic human dignity had begun to suffer tragic outrages. Benefits reaped from

years of democracy were being lost through an oppressive dictatorship that was extending its tentacles to even the most marginalized sectors of our society. Chile became divided into those who had been tortured and those who denied there was torture, between those who barely survived on the miserable basic wage and those who purchased a little more of the country with another fistful of dollars. Each time I returned, I saw the country more shattered. With this dissolution, I felt resignation spread to every corner as people grew tired of fighting in vain. The years of experience etched in my memory confirmed that with the military coup of September 11, 1973, the death of President Salvador Allende, and the seizing of power by the junta headed by General Augusto Pinochet, the course of Chilean history had been changed forever.

One return trip brought me in contact with a group of women who embodied the tragedy that my country was then experiencing as well as the force of an eternal, timeless struggle. That memorable summer day was my first encounter with the *arpilleristas* of Santiago. It was my first visit to the Vicariate of Solidarity of the Catholic Church of Santiago. There, I found myself before a myriad of handicrafts made by political prisoners, mothers and wives of the disappeared, or simply people who had to support a family in Chile during those difficult years. The majority of these works in copper, wool, and leather were representative of my country's outstanding folk art traditions. However, upon closer inspection, I realized that the messages of this "new" national folk art were radically different than those of the traditional handicrafts found in the local stores and fairs.

I was confronted with expressions of anguish and despera-
tion, with a series of messages that wanted to be voiced
through whatever means to all those beyond the confines
of Chile's dreadful reality. Although all these objects
caught my attention, I was particularly impressed by a
group of appliquéd and embroidered cloth rectangles.
They were like gigantic books that sought to depict the
multiplicity of experiences of daily life. These were the
arpilleras. It seemed the *arpilleras* were compact records
of the misery and suffering of all Chileans. I examined
them at length, one by one, to determine exactly what
were the stories they wished to tell.

I spoke that day with some of the women who
were volunteers in the Vicariate's Workshop Department.
With their help, I came to understand certain symbols
that were repeated on each of these representations of
daily life, and I discovered the true history of the
arpilleras. As I learned to interpret the unremitting
experiences portrayed in this social art, I realized that I
had to do more than photograph them or merely "read'
them, I had to look for the source of all these histories
written in fabric.

After just one visit to the National Vicariate of
Santiago, I was determined to find the women who
created the *arpilleras*: the *arpilleristas*. With the assis-
tance of one of the volunteers, I attended a meeting with
the women who fashioned what can only be termed a
true language of silence, the silence through which the
daily history of our ravaged country has been recorded.

Seeking these silenced voices, I made my way to

the suburbs of Santiago. That hot Wednesday afternoon, I entered the humble parish church in the shantytown of La Pincoya. I was led down a passage to a room where a group of women were seated around a long table. These women formed one of the workshops dedicated to the production of *arpilleras*. I felt as if I were witnessing a group therapy session where the women could freely give and receive emotional support. All the women were talking without a pause, speaking of anything and everything while they cut and embroidered the cloth. I had the impression that each wanted to be heard uninterrupted. I slowly approached the table — covered with baskets filled with scraps of cloth, wool, and partially-completed *arpilleras* as well as scissors and other tools available for use by the group — and sat among them to hear their comments. They all fell silent. It was as if I were an intruder in a stranger's house, someone who had interrupted an intimate family gathering in which the only participants were those who had lived together for years. With good reason! Why should they share with a stranger (in addition to the indiscretion of a camera) something as personal as the disappearance of their son or their husband's imprisonment? Why should they recount — and how could they summarize in a few minutes — years of daily hardship, and physical and emotional torture?

After a while, I tried to break the uncomfortable silence by telling them about my experiences while a student at the University of Chile. I described my life at the Macul Pedagógico before 1973, my involvement with

Popular Unity, Salvador Allende's visit to our university, and everything that represented our political and social awakening. I told them about my unforgettable compañeras: Helga, Mónica and Corina (all of whom I never saw again). I related the dreams that gave meaning to our ideals during those years, my years. My stories were fantasies to them. The world I described had to seem a fantasy compared to the terrible reality then being experienced in our country. I and other university students "played revolution," and perhaps because we considered it a game, we lost everything. The women I now faced truly lived the reality of inhuman repression, day in and day out, without alternatives, without the right to criticize or protest.

My attempt at dialogue with the women failed. Our experiences were so very different. They didn't want to hear about Chile during Popular Unity (they were fully aware that their rights were respected during that period and that, for the first time in their lives, they had expectations of a better future) and they especially didn't want to listen to the reminiscences of a woman who had lived a privileged life: first as a student in a private Catholic school for "ladies," then as a university coed, and finally as an immigrant to the promised land where you earned dollars and dreamt in English. To them, I represented the impossible. I had escaped pain, torture, and political persecution, and then had returned to look in from the outside; from my vantage point as a privileged woman, I had come to observe the individual tragedies they were obliged to suffered in our country.

23

I later returned to the group after realizing that it was I who truly had to listen — not to the details of the terrible stories they had to tell, but rather to what they said about their work, for that was really the way they expressed themselves, with few words. An idea, the needle, the apron, scissors, a scrap of fabric and the hands begin to speak. . . that is the way it all began. At that second meeting, the hours slipped by unnoticed. They explained how they had begun to work as a group and how each *arpillera* was formed. From that moment on, we set aside a our differences and united as women, as sincere, newfound friends in solidarity.

After the fall of Salvador Allende in 1973, those most immediately impacted found groups in the organisms of the Catholic Church that earnestly supported their search for their detained or disappeared relatives. The National Vicariate of the Catholic Church assumed a very important role by organizing aid centers for people who desperately needed help to survive the national catastrophe. A series of centers were especially developed to create workshops in the detention centers as well as in the marginal shantytowns of Santiago so people could earn extra money to maintain their family. The National Vicariate, along with other national and international groups, managed to distribute materials to the workshops and their participants. Correspondingly, they organized ways of selling the workshops' products in Chile (only through Vicariate workshops) and outside of the country. The *arpilleristas* were organized in 1975 and, from the outset, their works carried a clear political message. Some

24

members of the *arpillera* workshop also belonged to the Association of Families of the Detained-Disappeared. The majority of these women of all ages had met in the long lines at the jail or in the detention centers where they awaited news of a family member. The *arpilleras* were begun in those years to express what Chilean media could not say. This utterly silent social art was soon converted into the most effective clandestine means of communication to resist the military dictatorship of General Augusto Pinochet.

To the frequently asked question concerning the origin of this art form, the *arpilleristas* explained that, in part, this tradition comes from the famous embroidery of Violeta Parra (today, many remember her more for her music than for her visual art). Violeta Parra's tapestries were made over a foundation of burlap, the materials were usually brightly-colored bits of wool, and the themes were moments of daily life. Another possible influence were the embroiderers of Isla Negra (home of Pablo Neruda). However, these two traditions did not adequately accommodate the *arpilleristas'* need to express, through accessible means, the tragedy that affected their lives. They had to propagate a message, join with other women confronted by the same problems, and earn a little money to feed their family. From those sources and goals were born the *arpilleras*, the *arpilleristas*, and the workshops that organized them.

The women in the workshops clearly believed that their function was not merely the production of

arpilleras, but rather to indefinitely continue the tireless search for their family members, their loved ones who had disappeared or were in prisons awaiting sentencing for political "crimes." They considered themselves (as did the mothers of the Plaza de Mayo in Argentina) obliged to continue fighting until the end. From time to time they organized protests — sometimes this consisted in entering a grocery store, filling the shopping cart, allowing the cashier to total the food items, and then saying, "there isn't money to buy food in this country" before leaving the store. In others, at a predetermined time, the women of the shantytown opened their windows and made a deafening din with their empty pots to demonstrate they had no food to give their families. They would also gather and march in silence holding huge, empty bags on which were written the single word "Bread." These women held hunger strikes, chained themselves to the fence of the National Congress, and constantly paraded with photographs of their disappeared family members. In most cases, their protests ended in their being arrested by the police. We must understand that arrest had another meaning in the dictionary of General Pinochet's government: arrest meant torture, physical and mental abuse. During that time in Chile, more than ever, the individual was surrendering to the principle that declared the prisoner guilty until proven innocent: under this new legal system, those who committed a political crime wouldn't have the slightest hope of ever proving his/her innocence.

In 1984 I was reunited with those *arpilleristas* who

were also members of the Association of the Families of the Detained-Disappeared. We met on the patio of the Vicariate. At that meeting, we were all much more at ease. They were less afraid to tell me their stories and I wasn't terrified by the thought that I would end up another name on a list of *desaparecidos* when I left the Vicariate workshop. In previous years, I would feel an uncontrollable panic when I entered the Vicariate building. I imagined that agents of the secret police would take me away as a prisoner to some interrogation room. I always began my approach to the workshops by browsing through the books at the Manantial Bookstore, a shop located on the same block as the Vicariate. After looking carefully all around and behind me, I slowly climbed the stairs that took me to the workshops. Sometimes I noticed people in other rooms of the Vicariate who organized to help those who were arrested or injured during a protest. I tried to walk quickly by so I wouldn't witness something that I might later have to conceal during an interrogation.

That memorable day of December, I was allowed to photograph some of them while they spoke. I generally photographed their hands sewing, not their faces. I was asked not to show the photos of their faces in Chile. They told me that there were only women in the workshops, not only because they were the ones who searched for their disappeared husbands and sons, but also because in some way they had lost their fear when they saw that their husbands had lost hope. I was told: "The men are tired of fighting in vain, they are physically and emotionally drained. They are sick of the soldiers who take them

27

from their home at bayonet point every week, always detained as a suspect. . ." A second voice added: "Fear and desperation clipped their wings, but we women are like the wool: the more you mistreat it the taller it stands." Some women explained that their husbands didn't believe the method utilized by the group was for them and, moreover, other women were convinced that their spouses had accepted the idea that their disappeared children were dead — there was no longer anything they could do. Their activities in the workshops transformed the traditional role of the Chilean woman. Women went into the streets to protest and search for their disappeared family members. Not only did they suffer persecution and physical abuse as a consequence, but also the lack of economic support (traditionally supplied by the man, now imprisoned or disappeared) obliged the woman to accept complete economic responsibility for the whole family. The members of the *arpillera* workshops unwittingly changed the destiny of the working-class Chilean woman as they were forced to go from "lady of the house" to "head of household."

During several visits (many of them cancelled at the last minute due to protests or for "security reasons"), I heard innumerable individual and collective stories, far too many to recount. These stories used a language that could be read in each *arpillera*. Those cloth rectangles were the representation of an immediate reality: the only way to grant voice to that which had been silenced for so many years. Each *arpillera* began with an individual or collective idea concerning an outstanding current event, or a personal experience that one of the women wished to

constantly remember. From its inception, each piece was collective as well as individual because the women eagerly helped each other. An *arpillera* took about a week to be completed and, afterwards, it was turned over to the distribution organizations so it could leave the country. Many times, *arpilleras* either confiscated within Chile or during attempts to smuggle them out of the country were destroyed by government agents.

There was an extensive technical process employed in the creation of each *arpillera*. The backing material, usually burlap, was first cut in the form of a rectangle. To this was added the pieces of fabric that formed the background of the *arpillera* design. The background, in the majority of cases, featured the Andes mountains and a sun that was always shining from beyond the mountains. Then, clouds, trees, airplanes, trucks, cars, or some other objects were appliquéd to create a second layer. This constituted the setting for the story and, when finished, it brought the *arpillera* to life. The most interesting moment in the creative process came after the setting of the story was completed because, in that instant, the women exploded with emotion, anxious about how to express what they wanted the world to know. Telling their story began with the creation of the *arpillera's* doll-like figures. First, the heads were constructed from a piece of fabric that could be easily stretched and folded, it was stuffed with cotton or other filling, and then onto this small ball would be embroidered the mouth, eyes and, in some cases, other details. The hair could also vary according to the imagination of the *arpilleristas*. Black, white, gray, or yellow wool

could be used. Wool that was crimped because it had once been knit into garment, was employed to depict a person with curly hair; extended pieces of braided wool were added to figures that represented little girls. At times, the women even cut off pieces of their own hair to add a more natural — and very personal — touch to their doll. Through these details a wide variety of characters paraded before our eyes: old people with gray or white hair, blonde and brunette children, young people, women, and men. When the heads were completed, the bodies were made. Generally, the *arpilleristas* chose the fabrics and colors that would make the doll's clothing appear as realistic as possible. In many cases, the women used scraps from their own clothes to fabricate the garments of the *arpillera's* figurines. Sometimes, the dolls even bore the minute detail of undergarments. In the workshop, the majority of dialogue among the women was unleashed during the creation of the figures's body. Most of these dolls were born from the forces of repression and therefore, as these little beings were created and put into action by the *arpilleristas*, the women vividly recalled the events and personal experiences that were being portrayed.

The *arpillerista's* final step is to carefully place the characters in their proper positions. The women would sometimes joke about the doll's details or aspects of the scene into which it was being situated. But this was always a fleeting moment because a look of pain would immediately darken their happy faces as the group of dolls became men who were following a lone figure

through the streets, or arresting a member of the woman's family and taking him away. The arrangement of the dolls laid bare intimate memories and brutally personal experiences. When the moment came to make and situate the dolls on the *arpillera*, the women breathed life into their creations as they placed the figures as flesh-and-blood beings within their art. Often you heard comments like: "This is Doña Juanita in the door of the police station when she was waiting for news of Don Pedro," "Here we are at the protest rally on September 11," or "Here I am preparing food for children in the shantytown." With these comments the *arpillera* was completed. As a final touch, the *arpillerista* added an embroidered or crocheted edging of brightly colored wool. Some *arpilleras* had a small pocket on the back into which was placed a small piece of paper bearing the *arpillera's* theme, the name of the woman who made it, or simply a message that the *arpilleristas* wanted to send. The completed *arpillera* then joined many others in the infinite chain of a diary of life written with scraps of cloth, wool, needle, and apron. A true diary of "lives" that expressed to both them and us, through stitches and appliqué, what the women couldn't say with words. These women, through the years and by means of the *arpilleras*, left a silent testimony that many people refused to understand. These testimonies followed a course of history parallel to the history written in the books. The decades of absolute dictatorship and tyranny will live forever in each *arpillera* created during those twenty years.

The *arpilleras* are a symbol of the national history

of Chile. The women of the workshops met to organize as well as talk about the recent events of the country, and from those interchanges came the majority of the ideas not recorded in traditional historical texts but rather written in the pages of that parallel history. If a woman had recently lost one of her sons or her husband, when she told her story in the workshop the other women relived their own story. The women joined forces and the individual cause was regularly transformed into a collective one. This collectivity is one of the greatest merits of these messages. When we examine an *arpillera* at length we can be assured that it relates the lives of thousands of families, that it formed part of the most effected population of a slowly agonizing country. In addition, all the *arpilleras* are true photographs because they tell a history that goes beyond what we could understand in a single glance. The women of the workshops were photographers with a needle and apron who related to us, from their personal perspectives, part of a much more complex situation and the reality they have been forced to suffer. Like other photographic images, these scraps of cloth and appliqué spring from a way of seeing reality, of understanding it, and trying to interpret it. Through making *arpilleras*, the *arpilleristas* recreated their own lives and transformed them into photographic self-portraits. Their children are the little boys and girls we see eating at the tables in the soup kitchens, their sons are the ones being tortured by the CNI (National Intelligence Center), and they are the ones eternally waiting outside the doors of a prison or turning the pages of innumerable calendars to find that month in which their

disappeared family members would be returned to them.

But the *arpilleristas* did more than only embroider their pain and that of their people. Choosing again to utilize Chilean national traditions, they created a song and dance troupe. The women of the Association of Families of the Detained-Disappeared formed their "Folkloric Troupe" to perform songs that, like the *arpilleras*, denounced the dictatorship's human rights violations. In addition to their songs, they created the *Cueca sola*.[1] This traditional dance served to disseminate the testimony of pain experienced by the women of the disappeared. Gala, the director of the folkloric group as well as an *arpillerista*, described the purpose of the *cueca sola* in one of our meetings: "We created this *cueca* as a testimony of what we are living, and to fight so a woman will never have to dance the *cueca* alone again."

I have learned so much from the art of these women. I listened to them hour after hour and I followed them with my camera in many moments, for many years. I realized the great hope that their daily struggle gave them. Also, I discovered through their testimonies that their art/social work united them in their constant pilgrimage on the path to freedom — freedom not only for themselves and their families, but also all the citizens of their country, the continent, and the rest of the world.

I know that the *arpilleristas* told me their experiences fearfully, but behind that terror was the tremendous desire to have someone hear their stories and re-tell them in other countries with the hope that others, after hearing these women's lives, would help those in Chile defend

33

their basic freedoms, without which human dignity can never exist. Often they feared the very words they pronounced, a fear compounded by the fact that someone with a camera recorded their faces together with their words. They knew that both records would leave with me, fulfilling their desire to have others receive their individual messages sent from Chile. After repeated contact with me over a period of years, they slowly left their fears behind and welcomed me into their lives with the greatest confidence that they could, considering the situation in which they lived. Thanks to this unconditional confidence I managed to gather numerous stories along with silent images, testimonies of collective mourning for years of individual and mass deaths that we seem to have forgotten so quickly and easily.

In 1985 I returned to visit my mother — who died of cancer that same year — and to work on another photography project. Once again, I spent hours with the women of the workshops, and spoke with Violeta Morales who still seeks her brother and Toya who continues desperately asking about her father. I heard new songs performed by the folkloric group as well as visited the Association of the Detained-Disappeared whose members continuing writing with the *arpilleras* the history of the Chilean military dictatorship.

A few years after my mother's death, the bodies of *desaparecidos* began to slowly appear in common graves in the mountains and desert. I continued to introduce the *arpilleras* in different women's centers in the United

States, give talks in universities (from Arizona to Hawaii, from California to Massachusetts), and explain the history of the *arpilleristas* of Chile.

In the spring of 1989 I returned to Chile with a different project, but one which brought the *arpilleristas* and I together again. I had been contracted as a consultant by a Canadian company that was filming a documentary about the Chilean *arpilleristas*. It was quite a distinct experience because the country optimistically looked towards the upcoming elections: for the first time since 1973, the Chilean people could vote for the return of the democratic process. That 1989 meeting with the *arpilleristas* was awkward. I was asking them to publicly recount their histories for a foreign film company. That meeting was very similar to our first one in the marginal shantytowns of Santiago, where I had initially asked them to confide in me.

At that time, after so many years of dreaming about democracy, some of the women — the minority — confronted the possibility that their sons, brothers, and husbands were dead. However, I was most impressed by the fact that many of the women firmly maintained that they would never lose hope of seeing their disappeared loved ones alive again.

Other changes during these last few years were the deaths of several women of the workshops (the majority from cancer) and the extreme effects of profound emotional pain that brought on acute depression and finally madness in some of the *arpilleristas*.

Our documentary, *Threads of Hope*, premiered the following year in Toronto, Canada. The film received

the 1993 Peabody Award in New York as well as an
Emmy nomination. Yet the women continue in Chile,
making *arpilleras* in their small groups and asking:
"Where are they?" Chile saw democracy bloom again yet
the women did not find their disappeared relatives.

In 1994, more that 20 years after the military coup
of 1973, I returned to Chile to speak with the
arpilleristas. While the Chileans were electing the second
president of a democratic regime (Eduardo Frei), I taped
the testimonies of eight women whom I had not been able
to forget during my years of exile in the United States. I
recorded their stories so the pain and suffering of so many
human beings would not be totally in vain and so that,
upon reading their testimonies, we might learn the im-
measurable worth of human rights and teach future
generations to defend them throughout the world.

As I said farewell to the women of the workshop
that last time, I again had the terrible sensation that the
door of a gigantic prison had opened, a prison that kept
the past captive, and I was the only one permitted to leave
(as before, as always). My companions remained behind
without any hope that, in the future, their undying,
impossible dream of finding their disappeared relatives
might be fulfilled. From now until my final days, I will
hear the voices of the women from that far-off land and
the chorus of their song that the breeze carries over the
blue skies of Chile:

> For the persecuted idea
> for the blows received
> for the one who can't withstand

for those who hide
for the fear they have of you
for the surveillance
for the way they attack you
for your children whom they kill

I name you Freedom

For those for whom we search
for the guilty silence
for the answer denied
for the life we love
for the wilted rose
for the wounded son
for the struggle that never ends
for the disappeared

I name you Freedom

I name you on behalf of all
by your true name
I name you in darkness
when no one sees me.
I write your name
on the walls of my city
your true name
your name and other names
that I do not name for fear.

The breeze from that other continent often brings to my ears the murmur of the *arpilleristas'* voices and the folkloric group singing the *cueca sola*. Whenever I think about these women, each time I recall their testimonies and songs, I again remember those days gone by of the 1970s and the words of President Salvador Allende as he declared that Chile was writing the first pages of a new history. The women of the workshops wrote hundreds of pages more with their *arpilleras*. But theirs is a different history, a tragic history. Hopefully, it will ever serve as an example so we will never forget all the graves that eternally lie in silence, beside the one belonging to Salvador Allende. Maybe some day in the near future we will again take up the road and, together, we will write the remaining pages of our new history, unfinished for thousands of Chileans since September 11, 1973. Let us write the future, not forgetting the past, so that never again — either in Chile or in any other part of the world — will respect for human rights be lost.

[1] The *cueca* is a traditional Chilean dance that is performed with a partner. On March 8, 1978 the *arpilleristas* danced a *cueca* alone — a *cueca sola* — during a performance in honor of the International Day of the Woman at the Caupolicán theater. They wanted to demonstrate that the women needed their man who then was imprisoned or had disappeared.

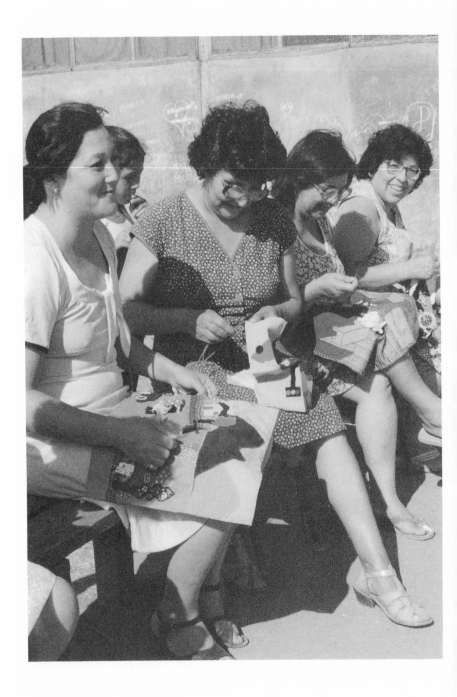

THE WAY TO JUSTICE IS LIGHTED BY TRUTH: TESTIMONY OF VIOLETA MORALES, CHILEAN ARPILLERISTA

I am Violeta Morales, sister of Newton Morales, who was arrested and disappeared on August 13, 1974.

Since the military coup of September 11, 1973, we knew that my brother was going to be arrested because he had been a non- commissioned officer in the Chilean Navy. He had retired because the constant trips to the Antarctic had damaged his kidneys. He had never been political nor had participated in political activities. After retiring from the Navy he went to work at the Sumar factory, a polyester plant. There he became a militant of the MIR. With his navy training as an electronics engineer it wasn't difficult for him to soon get the job. Never before had he been politically militant, because while in uniform he always spent long periods on ships and didn't have the opportunity to become affiliated with any group. He never had the connections to become active in the political parties. After working at the plant for a few months, his fellow workers elected him president of the union at the Sumar polyester plant. Because of that we, his family, knew that they would be looking for him. After September 11, 1973, the military junta immediately came out with a decree ordering everyone who was a union leader to report to work. My brother Newton

wanted to report because he said, "I haven't done any-
thing, I'm not afraid." So he was going to report, but we
didn't let him. So he stayed home and didn't go to the
plant, but he had to keep moving from one family
member's house to another. They were searching for him
because of his past, because he had been in the military —
that was the main reason.

Before the coup, at the Sumar plant, there had
been a worker uprising. Troops had surrounded the plant
and armed helicopters constantly circled over the plant.
During this uprising, some workers shot at one of the
helicopters and killed the pilot. After that incident, the
government began to look for ex-military employees at
the factory in order to arrest them and blame them for
the death of the pilot. And because there were several ex-
military workers at Sumar, after the coup several workers
were arrested, others immediately fled the country and, in
the case of my brother Newton, we wouldn't let him
show up for work. In order to throw them off the trail,
my brother moved from house to house, and, at the same
time, he was helping people to organize. It was difficult
for us to watch how my brother gave of himself totally to
help others. He didn't even have time to eat, he had to
eat on the run. He was always in a hurry and would drop
everything to help other people organize against the
dictatorship so that it wouldn't become as powerful as he
feared it would.

I was alone with my five children--my husband
had left me for a woman from another political party.
Newton supported us and helped us all, including my
sister who was then studying journalism at the university

42

and, also, my mother. He helped us with his Navy pension, the salary he received from the Sumar plant, and the little he earned from a construction company where he also worked. He did everything he could to support us. But after the coup he lost everything, the pension and the two factory jobs. Before, we always had food in the cupboards and never lacked for something to eat. My mother ended up selling her jewelry and small valuables, which helped us to last for awhile. With that money we supported ourselves, but eventually that also ran out. I had heard them tell my brother that "life isn't worthwhile if you don't offer it to help your fellow man," and I would ask him, "How can we not care about life if it's the most important thing we have?" Later, with time and struggle, I learned and understood what my brother really meant to say. Living on your knees isn't being human.

Well, getting back to our story, my brother began to live in a clandestine way and it wasn't very hard for him because he had several identification cards showing he was a Navy officer. So he was able to move about freely — when he was out and they'd stop him, he just show them his identification cards and they'd let him through. But then our mother got sick and my brother decided to go see her. They followed him and were waiting for him. The next morning, three men and a female prisoner arrived at my mother's house and they took him away. Later we found out that the woman was Skinny Alexandra.[1] The first time that they came to look for my brother, my mother was alone. The men asked her about my brother and told her they were his associates from work. Later they returned at 9:00 at night. No

one else had come home yet. I had left with my children because one of them was having a birthday. They waited for my brother. No one had a chance to warn my brother. The men pretended to be friends from work and my mother believed them. When my brother got to the house, the men took him by the arms and my brother said to my mother who was in the kitchen: "Mama, the DINA are taking me away."[2] My mother didn't understand because she had never been politically active, so she didn't know what was happening. The men tried to calm her down when she grabbed hold of my brother. One of the men took her by the shoulder and said, "Don't worry, Ma'am, he'll be back in ten minutes — we're only going to talk to him because we're friends of his from work." My brother was pale and said nothing, surely so he wouldn't scare my mother. My poor mother believed that they would bring him back soon. After awhile, my sister returned from the university and a neighbor told her that they had taken my brother away in a red van with an antenna. After talking with the neighbors we found out that our entire neighborhood, the Villa Frei in Nuñoa, had been surrounded by armed young couples who pretended they were out on a date. The entire neighborhood was surrounded so that my brother couldn't escape behind the houses. Just as they were taking my brother Newton from the house, my other brother arrived and followed the van with his taxi. After a short distance, he was able to see that they took Newton to a place close to here, near the Church of Saint Francis, to what we now know is London 38.[3]

After our brother disappeared we began, like other

families of prisoners, to look for him everywhere. In 1974, in July, DINA had been formed, and it was refining its methods and applying them brutally. We began to make inquiries right away and found out that in the Pro-Peace Committee[4], that was on Santa Monica Street, they were receiving all kinds of reports of human rights' violations. We also began to look for our brother in the jails, cemeteries, morgues, police stations and wherever there might be a government office. We also went to the courts, and in a lot of those places we were threatened with machine guns for asking questions and looking for disappeared prisoners. We sent thousands of letters to foreign countries, begging for help. We even sent letters to the leaders of the dictatorship, but nothing came of it.

In the Pro-Peace Committee we realized that every day more and more people arrived with the same problems we had. After meeting with so many people, we decided to form a coordinating committee in order to get better organized. Without giving our names, we took turns directing the organization so that we all had a chance to learn and gain experience on how to look for help for our cause. Father Daniel, a French priest who was driven out of Chile and who is now in Peru, together with a nun named María de los Angeles, were the first to help us in the Pro-Peace Committee. They welcomed us, and gave us support and advice during those first moments of desperation and sorrow. My family took turns — my sister, my brother, my mother, and myself — and we went every day to Pro-Peace and everywhere we believed they could help us in the search for my brother. For a long time they followed my mother in the street or

came to our house to interrogate us about my brother's activities. My mother became ill, so the doctor recommended that she leave off with everything and go far away to rest in a quiet place. We continued the struggle. My sister dropped out of the university and became part of the daily search with the rest of us. They followed all of us through the streets and stopped us to ask us where we lived and where we worked. They made life impossible for us. In the Pro-Peace committee we began to organize more, and we'd get together in groups to visit other places. One time we went to Puchuncaví, and afterwards they told us that my brother had been taken from London 38 to the Villa Grimaldi. We even went there as a group. After then, we went to 3 Alamos, where they also isolated and tortured political prisoners. One time, my sister went to 3 Alamos and managed to speak with a female prisoner who told her that three people had left from London 38 for 3 Alamos but only one person had arrived, the other two had been dropped off on the way. According to the description, the one who arrived could have been our brother. We were never able to officially confirm the information. We went to 3 Alamos several times. The guards would ask for things to give to our imprisoned family members. Later, the guards would give us back the torn bags — they themselves would eat the food we left. Sometimes they told us that visiting hours were 7:00 in the morning and, when we got to the prison, they would tell us the hours had been changed to 5:00 in the afternoon. We'd go back in the afternoon and they'd tell us that visiting hours were yesterday — they constantly made fun of us. On Christmas Day in 1974, a

lieutenant with red eyes, and I mean red eyes because you could see that he was up all night, told us that my brother was famous in that detention center. According to him, they called my brother "Newton the Tough" because he could take the physical punishment, "the Intellectual" because he read a lot, and he also had been given the nickname "Sarge" because he had been in the military. That day, Christmas Day 1974, we asked the red-eyed lieutenant to give us the chance to see our brother and to speak with him, even if just for a few minutes. He went inside and, after awhile, a policeman came out and said, "Newton Morales has never been here." I was with my sister-in-law and she was holding her baby and, because we didn't leave immediately, they put a machine gun to the baby's head and told us that if we didn't go, they would shoot the baby.

Since we were left without any money with which to live, my mother went to the Department of National Defense Funds to ask that they keep giving her my brother's pension. This administrator sent a letter to the administrator of 3 Alamos and, as the letters were going from administrator to administrator, they let my mother enter the precinct for the first time. She went in and says that you could see the barracks where they held the prisoners. In one of the hallways, at a distance, she saw my brother leaning against the wall, wearing dark glasses and hunched over. At that moment they took her arm and made her go into an office. The officer left her there and went to the office next door to prepare a document for signature and, as he was typing, he was saying out loud: "I, Newton Morales Saavedra confer this power to

47

my mother Regina. . ." Right then, she heard someone enter and say, "What are you doing, officer?" My mother heard the piece of paper being yanked out of the typewriter and the man yell, "Go tell that woman that her son has never been here." The first officer comes back and repeats to my mother that Newton had never been in that prison. Before they took my brother to 3 Alamos, my mother saw him go by in a car with two men, driving through the neighborhood, so that he could help them recognize people that they could arrest. Also, they stopped my mother many times near her house to threaten that if she didn't stop causing trouble by looking for her son, she would lose the rest of her children, too. My other brother lived all the years of dictatorship without work, harassed and without the possibility of leaving the country. My brother Newton didn't even want to leave because he always said, "I am not going into exile. Someone who hasn't done anything, shouldn't be afraid." He never thought that in his country, where even the worst criminals have the right to a hearing, he would end up without justice. He was always sure that if some day they arrested him, he would have the right to a trial and they would see that he was innocent. But here in Chile it wasn't so. There were abuses of power by the military, they eliminated everyone who thought differently from them without a single law that said that to think differently was a crime. They imposed their own laws. And so we struggle on and in order to find our loved ones and fight against the human rights' abuses, we keep on working with Pro-Peace.

In the beginning, we didn't even have the money

to pay the bus fare to go to the Pro-Peace offices. Because of that desperation came the idea of making the *arpilleras*. We remembered the activities of the needleworkers of Macul and the works of Violeta Parra, but we wanted to do something different. We didn't want to make something that was only decorative — we wanted something made by hand that would denounce what we and our country were experiencing. We wanted to tell people, with pieces of our very clothing, about our personal experiences. We wanted to sew our history, the hard and sad history of our ruined country. At first we had a problem with getting materials, the cloth and wool especially. From that came the idea of cutting up our own clothes and unravelling our own sweaters. From those materials came the first *arpilleras*. Our workshop started in 1974 but wasn't made public until 1975. During those years, I took on all responsibility for the search of my brother. My sister had been kidnapped by a taxi driver who questioned her about some names that she recognized. The taxi driver told my sister about her years as a volunteer in working-women's organizations, and he knew all about her activities as a university student. After that incident, my sister began to be afraid to go out in the street to look for our brother. So I assumed all responsibility of the family and the search for my brother Newton. The truth is I was also afraid, we were all afraid to keep asking questions and looking. At that time I devoted myself totally to the *arpillera* workshop — that was what kept me sane at times. There I found other people who were suffering the same experience, and my interest in helping them sometimes made me forget my own

tragedy. During those years the "List of the 119" appeared. This list appeared in the newspapers, in the VEA especially, and because of this list and the problem of a certain prisoner who had escaped from Colonel Manuel Contreras, our work became more dangerous. The case of the prisoner was terrible. An arrested man told Colonel Manuel Contreras that he had an informant who was inside the Pro-Peace Committee. One day, troops surrounded the entire sector around the committee's office, and took the prisoner there so that he could help them. The prisoner managed to escape and ran inside the committee office. We (the *arpilleristas*) were there and we helped him. We let him come inside with us and took care of the wounds they had inflicted on him when he was tortured. Colonel Contreras tried to enter the office with soldiers but the committee didn't let them in. There were a lot of churchwomen in that committee and he couldn't attack them. He couldn't get in. That same night, Colonel Contreras met with Pinochet and they decided to shut down the Pro-Peace Committee. At the same time, they expelled the Lutheran bishop and Father Daniel, who had been a great support for us. Soon after that incident, the Chilean cardinal M. Silva Henriquez organized people to form the National Vicariate of Solidarity. So at the end of 1975, beginning of 1976, we sent *arpilleristas* to the Vicariate. In our new "home," we continued fighting by looking for the disappeared and creating more *arpilleras*, out of our own clothes or whatever piece of fabric we could find, so as to continue the denouncement. We channeled the *arpilleras* through the Vicariate for export to other countries, especially Canada,

France, and the United States.

Later, they needed people to take charge of the western zone of Santiago. So another volunteer and I went to teach and organize women who were out of work. When we arrived at that center, we were surprised to find that they wouldn't accept women who were family members of disappeared prisoners. It was a great shock for us. They rejected us and called those from the Vicariate "The Political Women." We didn't understand anything about politics — we were used to the fact that here in Chile it was the man who handled political things, we women dedicated ourselves to the home and to the children and that's all. We were used to the husband coming home with a paycheck, or that he would take off with the money, and the woman had to make do as best she could to raise the children. She had to perform miracles to get food, often leaving home to wash other people's clothes. The Pro-Peace Committee had already created shops where women went to wash clothes so they wouldn't die of hunger with their children. Although we had suffered that first violent rejection, we began to organize — as best we could — more workshops for washing clothes, raising rabbits, sewing, making brooms and baking bread. But the favorite workshop was always for *arpilleras*. More and more, we were teaching and learning the art of creating an *arpillera*. We were the first ones to create the *arpilleras* of denouncement and now, after 20 years, we are still the ones who make the *arpilleras* of denouncement. A lot of things have happened to me because I wanted to organize the women and distribute our message of denouncement to the whole

world. I remember, for example, one morning when I
was in a big hurry to take ten *arpilleras* to the center. A
lot of times we didn't even have paper with which to
wrap them, so we tied them together with rope. That day
I had left running from the house, and it seems that I
didn't tie them together very well. . . what happened is
that when I was passing in front of the guard at the Diego
Portales building,[5] I dropped that bundle of *arpilleras* on
the ground. The guards came to help me and I grabbed
them up as best I could and left walking, very fast, terri-
fied, with the *arpilleras* of denouncement clutched to my
chest. On another occasion, a "gringa" who had come to
the workshop to buy *arpilleras* tried to leave the country
with the *arpilleras* of denouncement and they caught her
at the airport. The woman was scared and said that
Violeta Morales had sold them to her. I was afraid for
some time, it was very difficult, but the Vicariate peti-
tioned for protection and they managed to protect me
from arrest. I don't know how they managed it because
here, in this country, they don't respect any process of
justice, it's a miracle if you're saved. A little while later
because of the wide distribution of *arpilleras*, an article
came out in the newspaper slandering our work. They
blamed a priest who was inciting us, and from then on we
began to be persecuted again. They followed us and
searched our homes for revolutionary material or
arpilleras. During that time, I would get up at dawn to
keep looking for my brother and I wouldn't return home
until nighttime, so my children had to learn to take care
of themselves, to cook and clean the house alone. When I
arrived home late at night, after my children were asleep,

I'd begin to make the *arpilleras* and, at times, I would work through the whole night. That helped calm me down a little, to stop thinking about my fear, and to earn a little extra money so I could feed my children. By making *arpilleras* through the night, I was able to sell them through the Vicariate and earn money for the family. I got used to not sleeping. Sometimes I went more than two nights without sleeping because I was making arpilleras and, during the day, I went out to organize more workshops and to help other women in the search for their sons, husbands, brothers, fathers, etc.

In the same *arpillera* workshops, we began to form instructional groups to teach women their solidarity role with the soup kitchen and other group activities. Sometimes it was hard to instruct the women of the shantytowns because they treated us worse than lepers — they believed that because of our activities of denounce-ment they would end up in jail or disappeared. It took a lot to get it into their heads that if we don't unite and help each other, we wouldn't be able to do anything. At times, the money we got from the sale of the *arpilleras* went to pay the doctor for a child or for medicine for some family that was part of the workshop. After the first years of dictatorship, the poverty of we poor women of Chile was horrible. In some houses they used furniture to make fires to heat the home or to cook food. Because to that, besides not having work or money to buy food, in most of the houses in the shantytowns the only thing that was there were mattresses thrown on the floor. We *arpilleristas* not only wanted to denounce the disappear-ance of our loved ones, but also we wanted people to find

out about the poverty in which our compañeras in the shantytowns lived, and the terrible abuses that the military committed in our country. We wanted to shout our outrage to the world about the horrible offenses to humanity and the crimes being committed every day against the basic rights of the individual. Our country had never seen more prostitution than in those years when the poor woman didn't have work or a means to support her family, and went out in the street with her daughters to work as a prostitute. We didn't have any help, we were very alone at that time. It seemed, sometimes, that the whole world had turned its back on us. On this planet there didn't seem to be any politicians, union leaders, or anyone who could help us organize and give us the basic ideas about how to survive the tragedy. I think now, after so many years, that if, back then, we had had leaders, maybe we would have been able to stop the coup before it had done so much damage in our lives. For us women of Chile who were involved in the fight, it was all the more difficult because we realized that our men were so macho. . . instead of helping us during those years they shoved us down. Some women's husbands didn't let them attend the meetings or help in the instruction or the solidarity work. Back then, the man never said, "Compañera, let's go fight together to change the situation of our country." It was the woman who fought, the woman who was raped and beaten, and never received help from her family. During the process of fighting for the liberty of my people I, as a woman, realized that this myth they had put in our heads our whole life--that a man has the power and physical strength to control everything

(of course, that is, up to a point) — is very relative and doesn't stop being like all the myths they instill in us women. It was the females, the compañeras, who managed to stop the military nightmare in our country — the woman has the strength that the man never has, or if he ever had it, he lost it. The woman, who always took care of the house, roused herself and didn't bow down again until she had returned liberty to her country and her people. It must be remembered that is was us who organized the first protests.

Some years after organizing the *arpilleristas* in the Vicariate, Father Pepe Aldunate formed a group of laypeople and approached members of our organization, asking that we join them and create the Sebastián Acevedo Group. I joined that organization because it interested me that those people were focusing on the problem of torture. I was the coordinator of the group and worked with a lot of people who were later thrown out of the country. Our group of *arpilleristas* passed out a lot of material in those years. I remember that we gave out, besides the *arpilleras*, doves made from paper and wool, posters, handkerchiefs, or whatever would let people everywhere know of our tragedy.

We were desperate to get our message out, we wanted, like our people had done so many times, to turn to other art forms — we wanted to also express ourselves in our song and dance. We wanted not only to embroider and shout our pain, we also wanted to sing our message of denouncement. So we began to organize people by zones to form song and dance groups. With about 15 people we formed the first folkloric group, and we debuted March 8,

1978, the same day that International Woman's Day was celebrated in Chile. We performed in the Caupolicán Theater with a group formed completely by family members of disappeared prisoners, the same women who we had known for years making *arpilleras*. I remember that, while we were singing in the theater full of people, CNI[6] agents and soldiers with machine guns waited for us in the wings. We will never forget that day because it was historic, a united human mass ready to rise up against the Pinochet's repressive government. We women began that protest that, later on, no one was able to stop until the military fell. We called the group "The Folkloric Group of Families of Disappeared Prisoners." Our uniform changed over the years, and today it is a black skirt and a white blouse. We do a lot of dances, the main ones are the *cueca sola* and the *tonadas*. However, we try to sing the more indigenous rhythms of our national folkloric tradition. For me, personally, the songs I like best are "The Owl" and the *zamba* "They Say That It Isn't Certain" because they speak of the search for a loved one.

When I wasn't working on the *arpilleras*, participating in the coordination of the Sebastian Azevedo Group, or involved in the folkloric group, I spent most of my time looking for my brother and helping with other solidarity tasks with my compañeras. I was very, very discouraged to find out how many compañeras we buried every day who died of cancer. It was hard to stop thinking that with the lives we were leading, that some day it would be another compañera's turn, and we might die without having found our disappeared family members. From 1973 until now, 1994, I have always worked in all

the groups that I could, organizing the women of the shantytowns. I put aside my own life. Because for all of us the Pinochet dictatorship forced us to exist but not to live. The dictatorship forced us to give up everything because we had to fight against the torture and the violations of our human rights, and to look tirelessly for our loved ones. I couldn't share those years with my children, with a man, or with the rest of my family. Moreover, after the 17 Day Strike,[7] I began to have health problems. I had constant hemorrhages and, because I came in contact with different gases used by the government defense troops, I developed asthma.

My future doesn't hold much promise, either. I will never have retirement pay or any type of social benefits, because for 20 years I dedicated my life to being a volunteer in constant solidarity work--I gave my life to others, and to the fight against the dictatorship to defend our human rights. Now, after almost 20 years, they offer us the law of the "Final Point," they want to silence our pain, but we will continue as long as we're alive — searching, hoping and asking the four winds. . . "Where are they?" We continue on with the same strength that we began with 20 years ago. We will not accept the Final Point Law or any other law that puts a price on our disappeared sons, husbands or brothers. We will continue making *arpilleras* of denouncement and we will continue protesting. In June 1993 we chained ourselves to another fence, this time it was the new Congress, so that the politicians would listen to us. This year, 1994, we danced the *cueca sola* in front of the Moneda[8] to keep our fight alive. We have to find something, even if it's the bones of

our disappeared family members. There is still a lot to do. We will continue with the solidarity that we've always had, hoping for a response from the future governments. It is sad that the organization is getting weaker and we aren't making so many *arpilleras*. I thought that people had generated more political and social awareness, but it seems we haven't learned much. I hope to God that the *arpilleras* remain as a testimony so that other generations, not only in Chile, but also throughout the world, learn much more than what we have learned.

— The Association of Families of the Arrested-Disappeared, Santiago, Chile, January 1994.

[1] Skinny Alexandra was supposedly a member of the MIR who, like other prisoners, became a torturer after herself suffering physical and psychological torture. Before the coup she was a student at the University of Concepción. Human rights defense groups have testified about her particular case.
[2] DINA was the secret police formed during the military government.
[3] London 38 is one of the sites where political prisoners were confined and tortured during the epoch of the dictatorship.
[4] The Pro-Peace Committee was formed to aid people that needed help. It was organized by the principal churches.

[5] At that time, the Diego Portales building served as the government office of General Augusto Pinochet.

[6] The CNI was the Center of National Intelligence at that time.

[7] The 17 Day Strike occurred in May 1978, and was the third hunger strike by the arpillera group. In response, Pinochet's government promised that, through the mediation of the Catholic Church, to release information to the families of disappeared prisoners. To date, this promise has not been kept (1994).

[8] The Moneda is the governor's palace in Santiago, Chile.

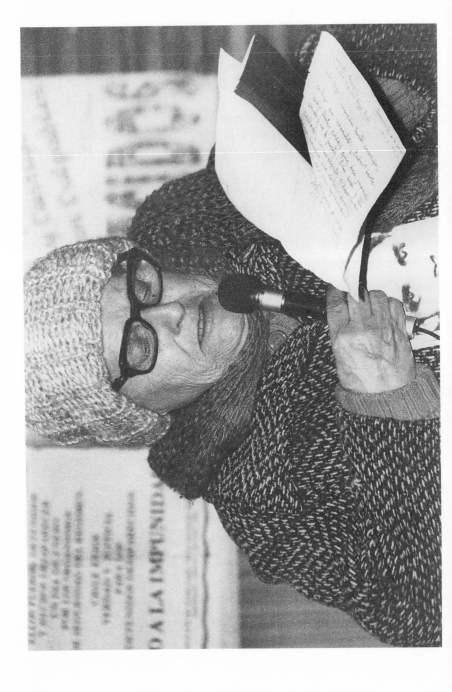

SO THEY DON'T FORGET YOU: TESTIMONY OF INELIA HERMOSILLA SILVA, ARPILLERISTA AND MEMBER OF THE FOLKLORIC TROUPE OF FAMILIES OF THE DETAINED-DISAPPEARED

I am Inelia Hermosilla Silva, mother of Héctor "Tito" Garay Hermosilla, who was arrested and disappeared on July 8, 1974.

My son was arrested on July 8, 1974. That night I was coming home from downtown Santiago, from my job as a clerk at the Crillón Hotel. As I was going upstairs to our apartment, I met up with four men who were climbing the stairs in front of me. I didn't recognize them so I asked if they needed help and what apartment number they were looking for. . . they didn't answer me but moved to one side to let me pass, and I went into my apartment. After a while, the doorbell rang. I opened the door and recognized the men from the stairs. One of them asked for "Titín." I thought that he was one of my son's friends. I told him that he still hadn't come home from the university, but he was certainly on his way. My son always left notes telling me where he was. That day, he had left a note saying he was taking a math exam. I told that to the men and explained he should get home about 9:00 that night. While I was still talking to the men, my son Tito came up the stairs. I told him that these gentlemen were looking for him. I asked Tito for his portfolio so I could take it inside and one of the men

said: "No! Don't take anything from him, we need everything." Right then I knew that they weren't my son's friends even though they had asked for "Titín." I suddenly had a bad feeling. The men looked at me and said they needed to talk to my son downstairs for a few minutes. I began to panic. When they started down the stairs I didn't think twice and followed right behind them. They told me not to worry, nothing was going to happen, and soon Tito would come back and tell me everything. I kept following them and wouldn't take my eyes off of my son. When we got to the second floor, one of them tried to make me go home, saying they would return my son before midnight. Another one yelled that if I followed them I'd have to face the consequences. I didn't pay any attention and hurried to try to keep close to Tito. When we got downstairs, two men took him and threw him in the back of a dark van. From inside the van, a man with a machine gun hit me hard on the chest and I stumbled backwards. They closed the door and some other men punched me and when I fell down they kicked my shoulders and stomach. It seemed I didn't really feel physical pain just a tearing in my womb like when my son was born. I felt a mother's pain and desperation, the feeling that they were taking a piece of my life with them. I thought the worst. I was lying on the ground, unable to move. It was all like a dream — or maybe a nightmare, a terrible nightmare that I can't ever wake up from. I stood up as best I could and, with a lot of difficulty, climbed the stairs to our apartment. I opened the door and screamed: "Lola, they've stolen Tito!" My daughter came running, she couldn't believe

what I was saying. She said we had to calm down and wait a while to see if they'd bring him back. I refused to wait. My mother's intuition told me my son was suffering and I had to rescue him as soon as possible. I ran to the home of my neighbor, Mario Espinoza. It was already about 10:00 p.m. Mr. Espinoza talked to us through his window and I yelled from the street that they had taken away my son. The three of us took a taxi to the closest police station to see if he was being held there but we didn't find him. We went to all the closest stations in Santiago that night but we couldn't find him. I'll always remember the terrible anguish of our first search that night, not knowing if they would torture him or just let him go safe and sound, because I was absolutely sure that Tito was innocent. We went home hoping they would at least call to tell us where to look for him. Nothing happened. Years later, we found out that Mr. Espinoza was one of those who had denounced the young men in the neighborhood. That was a shock, a betrayal I'll never forget.

A few days later, a married couple came looking for me at an apartment downstairs. A neighbor came with them to my apartment. The woman was crying and said their son had been taken from their home along with Tito. They explained that two men came with Tito to their house to take away their son. Later we found out that was a method they used to find the men they were looking for. They first arrested one of the friends, and then used the prisoners to get other young men to come out of their houses without resistance. Apparently in Tito's case, they took him to José Miguel's house, one of

63

his friends, to take him from the house without a problem. When they took José Miguel away, he was almost naked, they didn't even give him time to get dressed. They badly injured the boy's father because he tried to resist the detention of his son — they didn't show him any arrest orders or official paperwork and he refused to let them take his son in such a clandestine way — so he fought to defend his son and they beat him very badly then took José Miguel away. The father ended up in the hospital that night.

José Miguel's mother and I became friends because of our suffering. That woman joined me in my search. When you have a shock like that, you don't know what to do, where to go, who to talk to. When someone disappears, you traditionally go to the police for help, but in our country where the policemen themselves were involved in the disappearances there was nothing you could do. I screamed, cried, I even howled in pain without being able to believe that what I was experiencing was real, it all seemed like a bad dream. José Miguel's mother and I looked for our sons in morgues and detention centers, we submitted denouncements for alleged deaths — everything they told us we had to do we did. There were terrible times, like when they showed us naked corpses of people who had been shot and we had to clutch each other's hands to have the strength to look at the next body. It's so hard... you desperately want to find your son and, at the same time, you pray he isn't one of those corpses.

After they took my son, I left his room exactly as it was for years. I went in every day to make sure every-

thing was in its place for when he came back. I used to go
into his room to be with him: I talked to him, I asked
him to tell me where they were holding him, I told him
to take care of himself, to have strength and stay alive
until I could find him. I finally reached a point where I
couldn't tell what was real and what I wanted to be real. I
had moments of such desperation that my family decided
to take his things out of his room and lock the door.
When that happened, I felt my life was disintegrating and
they had taken him from my arms forever. My daughters
couldn't understand how I felt back then.

One of my daughters used to go with me every-
where and we'd look for names and information. Then
one day a policeman came up to me and, in a friendly
way, said: "Ma'am, I'm going to give you some advice.
Don't take your daughter to the places where you look
for your son because they'll identify her and it can be
dangerous for her." I'll never forget that advice because I
think it saved Lola back then.

I spent entire days in line waiting for the lists of
prisoners, long hours outside of places they took detainees
trying to find my son's face in those groups of young
men. . . but I never got an answer, I never found out
where they had taken him and what condition he was in.
We women found addresses of the places where they
interrogated prisoners and we'd stand outside waiting to
see if someone would give us information. A lot of times
they beat us and made us leave by using tear gas. We
withstood as best we could against the beatings, the tear
gas, and the high-pressure water canons (which often
threw us to the ground because they sprayed with such

force).

One day, during a long wait in front of a detention center, they were calling for family members of the prisoners, and they called out loud for any relatives of "Héctor Marcial Garay Hermosillo". . . . I couldn't believe it really happened! But I was ready, I'd been ready since the first day I started waiting at those detention centers. I had put some cigarettes, toilet items, and candy in a bag for Tito. I went up front to the soldier and he let me inside the jail. My legs were trembling as I walked in — I didn't know if in a few seconds I would find my son and hold him. When we got to the central patio I saw the families of other prisoners holding their relatives, but I looked around and didn't see Tito anywhere. I was overcome by panic: I began to shiver uncontrollably, I felt that everyone had turned to look at me, I suddenly felt very cold, and then I felt myself falling. When I came to, I was lying on the ground and the only thing I felt was an unbearable pain in my leg, I reached for it but didn't have any strength. They took me to the infirmary, and I found out that when I fainted I had broken my leg and now it wouldn't stop bleeding. The pain was the last thing on my mind — I only wanted to know where they had Tito. I started to scream, and one of the soldiers said there had been a mistake and my son wasn't among these prisoners. I insisted that if he was on the list he had to be with this group, but they kept giving me explanations I didn't understand. I refused to accept their medical attention. I got up and left the infirmary crying and shouting that I didn't want that kind of help because if they were capable of doing such things to other human

beings how could I trust them. I went in the street where the other women were waiting, and I got help and went to the hospital. My leg took a long time to heal, but I wouldn't stop walking and searching for Tito. After that incident, after knowing that he appeared on a list, I made contact with social workers to see if they could do something from outside the jail to find out where my son was. Nothing came of that process either.

In 1975 my son's name appeared again on a list from Villa Grimaldi, but a few days later a bombshell came out of Argentina with news that said "Chilean terrorists confronted — 119 dead. . ." Among those names was my son's. With two other women I immediately went to a pass in the Andes Mountains to try to recover the corpses and find out if they were really our sons. They detained us there, and then made us return to Santiago without information or photos of those who had died in the fighting. We never found out if it had been an massacre organized by the Chilean military or the Argentine government. Nor did we find out if our sons had died in that confrontation or if they were still prisoners somewhere else in Chile.

In one of our tours to other countries, I had an experience I'll never forget. We finished a recital in Canada for the defense of human rights, and when I was going down the steps from the stage a man approached me and said: "Ma'am, when you came out during the show and said the name of your son, I thought of my cellmate. . . it was your son." I felt my legs buckle. My friend Doris helped me and asked the man to come with us to the hotel. He came with us and told me the whole

story. He had been imprisoned with Tito — he remembered they called him "Titín" — and told me that my son always talked about getting out to help his mother or at least to call her. This man was set free and immediately left to live in exile in Canada. He didn't call me because my son never had the chance to give him my telephone number or address. He says that one day Tito began to bleed internally so they took him to the hospital emergency room, and my son never came back to the cell. The officials said it was an ulcer and they couldn't cure Tito in jail, but it was surely a result of the interrogations. That man later sent me a very long document naming other prisoners from those years in jail, in case it could help me. He explained in detail the brief conversations he had with Tito (brief because they kept the prisoners separated and incommunicado) and all the details he could remember to see if that document might help me find out where my son was. But his efforts didn't make any difference. That trip to Canada was also memorable because, three days before leaving Chile, one of the most admired and loved women leaders of our group died. We all left Chile broken-hearted. When we were visiting one of the organizations in Toronto that fought for human rights, we came across an *arpillera* made by Irma Muiller, the friend we buried a few days earlier. The shock was so great — that was one of the most difficult days of our tour — but, at the same time, we felt that she was traveling with us in spirit.

Everything that's happened to us has brought us closer together as mothers, wives, sisters, and daughters of the detained-disappeared. In those first years, we went to

the Pro-Peace Committee and from there to the Vicariate of Solidarity of the Catholic Church. We united into a large family that had to confront a similar tragedy. In that union we found the strength to fight. We organized into different committees and from that came the Association of the Families of the Detained-Disappeared. United, we went to work: we went on hunger strikes, protested in the streets, we chained ourselves to the National Congress in Santiago, we spent days outside the jails. We all suffered terrible repression by General Pinochet's government. They treated us like criminals because we asked about our disappeared family members. They had no respect for our pain, and they even physically attacked us. I had always been a housewife and a clerk, but without wanting to I became a woman with the spiritual strength to fight without limits. I realized that I had to commit myself politically in order to bring about social changes in my country. For me, politics had always been for men. I never dreamed that I could go out into the streets to protest or participate in strikes. I hadn't even belonged to a worker's union, no organization that was in any way political. The military coup woke up all the women, we were baptized by cruel reality: if we aren't conscious of what is happening in our society, we run the risk of ending up disappeared and under a brutal dictatorship the rest of our lives. I never thought that I — a loving mother and homemaker who washed clothes and cooked meals, the woman who went only from home to work and from work back home — would end up in street protests, arrested and in jail, beaten, chained to buildings, in hunger strikes, or so many other things that I've done these

last few years, only because they carried my son out of my life. It's sad that we'd find the path to commitment only when political tragedy touched us personally.

We women united to look for our disappeared family members, but also during our meetings we started to make *arpilleras*. The *arpilleras* were a source of income for those of us who had to leave our jobs and, at the same time, it was a way to calm ourselves spiritually so we could keep on going. When we met to make *arpilleras*, we would talk about our problems, bring back the pain of our most critical moments, and among ourselves help each other maintain hope. When we made an *arpillera*, we wrote our experiences and left a testimony of what happened in our country. When I was alone, I sometimes thought of my son Tito... some day he would look at the *arpilleras* I'd made and realize his suffering wasn't in vain. But now after making hundreds of *arpilleras*, that idea — the dream that my son might see them — has been slowly erased from my life. We began to make *arpilleras* with little pieces from the clothing of our own disappeared children. I tried to only use his old clothes so that when he came back he would have clothes to wear to the university. Little by little, as the years went by, I kept taking more clothes that were less used, and now I don't have much more than some of his favorite things that I put aside as remembrances. Maybe before I die, I'll make my last *arpilleras* from the new clothes he used just days before they took him away.

After a while we decided that along with making *arpilleras*, we had to continue our denouncements until democracy returned to our country. Our compañera

Gala Torres, who always had great musical talent, helped us organize and we created the Folkloric Troupe of the Families of the Detained-Disappeared. We began singing and composing our own songs. It took a lot for me not to cry when I sang and remembered my disappeared son — sometimes my words came out between sobs, they came out like a cry from my soul. The same thing happened to me with the *arpilleras*. I've made them about all kinds of themes, but up until now I haven't been able to make the one that represents my son's arrest. I know that I have to make it, but I haven't been able to. . . my tears drench the fabric and because of that I can't do it.

We still continue with our work, we forgotten people, for no one even talks about the *desaparecidos* now. The silence is calming the rage the dictatorship caused, and they're inventing solutions like the Final Point Law. I get furious when I think they'll prolong the oblivion of their political crimes when they haven't even given us our children's bones so we can bury them. A "final point". . . for whom? For the guilty? How can we have a final point if we don't find the guilty and know what really happened in Chile during the years of the dictatorship? So many women have died without knowing what happened to their sons, fathers, brothers, and husbands. There's no final point for them. They died without knowing the truth, without ever again trusting the justice system of their own country. Twenty-three mothers of our group have died — most of them from cancer — they could not have died in peace without knowing the fate of their own sons. My dear, unforgettable friend Irma Muiller, sometimes my greatest support,

died after fighting cancer for three months, and never found out what happened to her son, or even why he was arrested. We will always remember Irma, she was one of the true leaders of our group. She was one of those women who gave everything for her fellow man, fought shoulder to shoulder at each protest and in every strike, and always cheered us up when things seemed lost.

When I remember my son now, and think that I'll never see him alive again, I wonder: Why him? What did he do? We were always very close and he never told me he was in any trouble. He never said he was involved in political groups, he never got involved in any clandestine activities. When we heard on the news that the soldiers were arresting university students, my son never told me that he feared for his life, or what I had to do if they came looking for him or if he was detained. It was an enormous surprise for me to find myself standing in lines with mothers whose sons belonged to leftist political parties. I didn't know anything about anything, and that was the incredible tragedy, to see myself so little prepared, not knowing what to do or where to go. I even remember that the same night they took him from home, I treated the secret service agents like they were Tito's friends. I didn't know the gravity of the situation until they took him away and refused to give me an explanation.

After years I'm still as ignorant. I never found any evidence in things he wrote, in letters from his friends or someone who might have participated in something with him. . . there's no indication whatsoever that he was in some organized group. I keep waiting to find out the reason for his detention and disappearance. Every year I

make white handkerchiefs with his face painted in black to commemorate the date of his arrest. I distribute the handkerchiefs to friends as a gesture of love so that everyone will think more about his return than his death. My son was such a good boy and everyone remembers him like that. After my husband died, Tito went to work to help us. He always said he'd take care of us, that we'd have a better life when he finished his university studies. He spent every moment he could studying. He was a quiet child who never caused problems — not even when he was a teenager. His father died in 1970 and four years later they took him from me. My life totally changed. Now, what did I have to live for? I kept hoping that, perhaps, the soldiers would tell me what they did with my son and why. If they pass the Final Point Law, I promise I'll plant myself in front of the governor's mansion and no one will move me until I die or until someone tells me where my son is. They don't have the right to take away part of my life, because he was part of my life and without him there isn't much to live for. Before I die, I need to bury his dear body, I can't leave this world without knowing where he is. I know that I'm old, sick, and tired but I can't let sadness defeat me and my life end without reaching the closure I've been waiting for. I've forgiven a lot of people in my life, and I know how to forget, but I'll never forgive these vile men — not even at the hour of death will I forgive them, because they took from me a mother's most sacred thing: her child. As a mother, it's hard to understand someone who tortures a boy and then sits at home and eats with their own children, looks them in the eyes, and doesn't feel horrible

from the sadness. Maybe those men don't have sons or daughters? Maybe those soldiers never had parents. . . didn't they think about them when they were applying electrical current to a poor, sick old man?

A few years ago I completely accepted that my Tito was dead. I had a dream where I saw him plain as day. I saw him from the window of my room, I dreamed they were taking corpses out of the sewer and I recognized Tito's lifeless body. After seeing his corpse, I saw my husband walk up and he embraced me to console me. I felt that my husband, dead for so many years, came to console me because he and my son had met in death. That dream gave me peace and a little consolation. Now I ask for my son's body, his bones. I don't want them to deny my last and only wish. Why don't they give us mothers our last wish by telling us what was the fate of our children? Let us die in peace. They've already taken everything. Now, at the end of our days, after having unjustly taken our sons alive, after beating us, jailing and persecuting us, give us a single satisfaction: the destroyed bodies of our beloved children. I wish, I desperately pray, I implore them to tell me the truth. It doesn't matter how painful and terrible that truth might be, just tell me, I have the right as a mother to know what they did with my son's body. Even if they tell us that they tortured them to death and now they're all buried together in a common grave, it doesn't matter, we'll go and look for them. I'd go and dig up my child's bones with my bare hands, I'd hold them near my heart and then, again with my own hands, I'd bury them and ask my daughters to let my body always rest next to his remains.

I found out that in Patio 29 of the cemetery where all the crosses say "NN" — "No Name" — they buried some of those killed in Argentina. But we know they killed them here, they didn't bring them back from Argentina. But they won't confirm if that's true or a rumor. We can't go on walking through those graves, like I always do, looking for a sign that might lead me to his grave. Someone has to tell us the whole truth, once and for all. If the government won't say anything, I swear I'll spend my final days in front of the President's mansion and no one will take me from there alive. If they killed my son for no reason then let them kill me for a reason!

My son Tito was the only man in the family. I had him when I was older, and spent six months in the hospital without knowing if he'd be born alive. I took care of him and protected him every way I could all of his life--the soldiers had absolutely no right to steal him from me. After 19 years they stole him from me, unjustly, for no reason. One year, I went to talk to General Pinochet's wife, Lucía Iriarte de Pinochet, and begged her to help me find my son. The only thing she said was that she left her husband in charge of those things and she involved herself with other kinds of activities. I also ran up to Pinochet on Christmas Eve. My fellow employees told me that they were preparing downtown because the General was going to walk there. I left the hotel and I got close to him through the bodyguards without realizing that the CNI could have shot me. I yelled at him: "General, give me a Christmas present this year, tell me where they have my son!" Pinochet looked at me, his face twisted with hate,

and his bodyguards arrested me and took me away. I resisted arrest and kept screaming, "Where do you have my son, General?" They needed two men to carry me away but I never stopped shouting. They kept me detained all day with the usual abuses — we were no longer afraid of them, there were no surprises. But that detention was different because I wasn't with other women. In jail I kept shouting and asking them to take me where they had my son. I said to the policemen: "Wouldn't your mother do the same thing for you? What would you do if your son disappeared?" They couldn't control me. They hit me and it didn't even hurt. I was glad that photographers from foreign newspapers had taken pictures. I thought that would help put pressure on the government and my son would appear. I would have done anything and I'd still do anything to find him. At night, after my family paid the fine to release me, I went home aching, tired, physically and spiritually exhausted, but with the hope that this little grain of sand could contribute to finding my son. Nothing came of it. Everything was the same in our lives, in our Association. Another time, when Pinochet was walking from the door of the Diego Portales Building to his car, totally surrounded by bodyguards, I ran up and grabbed his legs, begging him to give me my son. In a second, they took me off his legs and pushed me into the police van.

Months passed and the idea of looking directly to Pinochet for answers kept turning in my head. One morning I went to the ministry of defense, where they said you could see Pinochet come downstairs surrounded by bodyguards. I ran between the men and began to

scream again: "General Pinochet, give my son back to me!" The general stopped, turned around, and asked, "What do you want, woman?" I said, "I want to talk to you, but they won't let me, General." He looked at me and said, "Come to the Diego Portales Building and I'll talk to you, tell them that I gave you permission." I went home so happy that day. All my friends thought I'd gone crazy. They didn't believe I'd talked to Pinochet, and even less that he'd given me an appointment to meet with him at the government building. The next day I arrived at 10:00 in the morning, explained what the general had told me, and they made me go upstairs to the waiting room. No one came after that to talk to me. Hours went by, people left to eat, they came back, and I kept waiting. It got to be 7:00 at night and no one could get me to budge from there. They called the guards and the secret service, but I kept sitting there. They wanted me to explain why I wanted to talk to the general. I insisted that I would only talk to him. They made me stay there while all the employees left. Afterwards, another soldier came out from the office and gave me a piece of paper. I opened it and it said: "Impossible to see you today." It was signed by Augusto Pinochet. I don't know if they wrote it or if the general really sent it, but I decided that for my own safety it would be better for me to go home without fighting any more. That was the last time I tried to talk to him. But I realized then that Pinochet was well aware of what was happening in our country, perhaps he even knew more about the *desaparecidos* than the other soldiers who were under his command.

Time went by and we didn't get any answers. I

arrived to retirement age, stopped working. and dedicated myself full-time to the Association. I began to make more *arpilleras* and performed more often with the folkloric group--of course, I continued with the strikes, street protests, and all the activities which the women participated in seven days a week, from sunrise until late at night, whatever time it might be. These last four years have been very difficult for me. I had a lot of illusions when I was voting in the new elections for the return of a democratic government. I thought that we'd then go back to walking in a free country and there would be justice for all those who had suffered this interminable persecution. But reality was different. Now I feel worse because I can't look to the future with any optimism. All our suffering, all our struggles seem to have been in vain. The return of political parties to our country, the opening of the National Congress, and the return of the courts of justice with their judges haven't changed anything in Chile. The political parties and the new leaders have dedicated themselves to fighting over political positions and to winning elections, but no one wants to talk about the violations of human rights. Everything is covered up by a silence of complicity. The guilty walk free through the streets of our country, the dead stay quietly buried, and the *desaparecidos* are absent forever. Lately, I think that I'm slowly losing strength and I'll end up losing my mind. . . I'll end up crazy like so many other compañeras. I have a heart like any mother that tells me to keep searching, but my head, my reason, tells me that he is already lost forever.

A terrible experience was when we found out that

they'd arrested a soldier named Romo and they were
going to present his case to the tribunals. Of course, that
was after Pinochet's government fell. A lot of women
visited Romo to see if he could tell them something about
their relatives. When I visited him, I nearly died when I
realized he was the same man from our shantytown who
had organized a lot of the young people into community
help groups in the early 1970s. My son Tito and other
men had worked as volunteers, repairing roofs and what-
ever else for people who were in a more precarious situa-
tion than us. Apparently this man, immediately after
September 11, 1973, joined the army and denounced the
young men who had participated in those groups that
volunteered with the poorest people in our shantytown.
He told me that he didn't know anything about the fates
of the men, that the DINA was responsible (the secret
service we had in this country). I'm sure he knew every-
thing but just wasn't capable of telling the truth. They
considered those young men as leftist extremists. I don't
know if at some time the volunteers participated in
political meetings or were in some party, but Tito was
always in the shantytown with other men helping people.
I've gone over our conversations in my mind, I read his
notebooks, his letters, I went through all the books he
had and what he used to read, I've spoken with his
friends, and nothing indicates that he had participated in
anything illegal or political. Even during the first days
after the coup, when we had to throw ourselves to the
ground so we wouldn't get hit by the bullets the soldiers
were shooting out in the streets, Tito never told me that
he was afraid they'd arrest him or that something might

happen to us. I was the one who was afraid because I knew this would be an enormous massacre where a lot of innocent people would end up dead. I wasn't wrong.

Maybe I'll wind up crazy, maybe I'll die of cancer, maybe I'll be shot during a public protest, but I believe my life doesn't have meaning if I don't live it right up until the end fighting to find my son. If the government doesn't help us, we'll join together in a series of new protests, we'll look for international help or to other groups in Chile. I'm ready to make any sacrifice, I've nothing left to lose. I'm old, broken, and tired, but before I die I will discover the truth about the disappearance of my son.

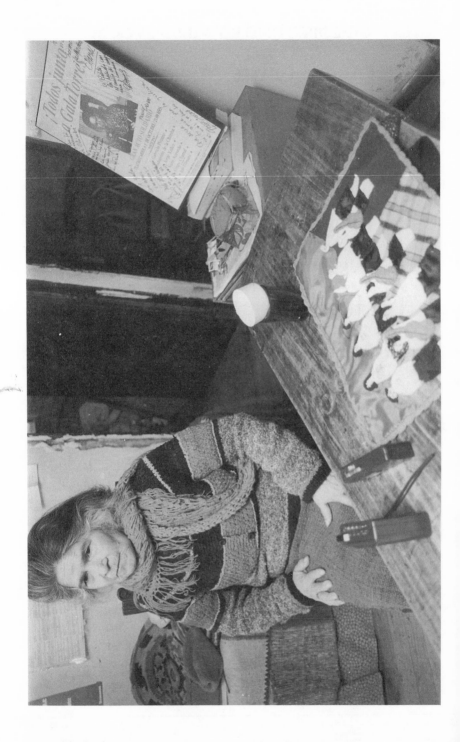

A PEOPLE UNITED WILL NEVER BE DEFEATED: TESTIMONY OF GALA TORRES ARAVENA, ARPILLERISTA AND DIRECTOR OF THE FOLKLORIC GROUP OF THE FAMILIES OF THE DETAINED-DISAPPEARED

I am Gala Torres Aravena, sister of Ruperto Torres Aravena, who was arrested and disappeared in October 1973.

We are from Parral in southern Chile, south of the Catillo Hot Springs. In October 1973, my brother and four other people were detained at the police station--that was his second and final detention, after that detention he disappeared. At the time of his arrest, Ruperto was living with his wife and one of his sons who was also married.

The first time, the police went to his home, arrested him and took him to the police station, and from the station they took him to the jail in Parral. They never explained the reason for his detention to us. Back then when the military or police took someone away, they would only say that they were taking the people in for routine questioning. After those interrogations came torture, disappearance, death. In the majority of cases there were no formal charges brought against the people who were detained. They also took my brother's son, my nephew, to jail. We never found out why they took the young man along with his father. No one explained

or said anything. There, they cut my brother's hair, they beat him, and they brutally whipped his son. After a lot of legal formalities, my family managed to visit them and take them food. The visits were always monitored by prison guards and we weren't allowed to talk much. We noticed the bruises, the signs of torture, and saw them becoming more and more wasted, especially my nephew who had never dreamed that such a beloved, small town — his town — could become a torture center for him and his loved ones.

My brother was very well known and loved by everyone in town. People mobilized, and some requested hearings with the police chiefs and other officials in order to prove that Ruperto was innocent of whatever criminal or civil charge so that the police would have to set him free. The pressure placed on the authorities got results, and my brother and nephew were finally released from the Parral jail on October 13, 1973. The police didn't find any evidence to bring formal charges against them. The day that they were released they were emaciated and still clearly showed signs of the beatings they had received, but they left happy, thinking that justice still existed in our country.

Ruperto's oldest son visited them after they got out of jail. During a very sad family reunion, my brother and nephew told the family about all the suffering they had endured in the Parral jail. Just a few days later, while they were eating lunch together, a policeman arrived with a message for my brother. The message told him to present himself at the station because they had received a long distance phone call for him. His sons told him to go

quickly and that they would wait until he returned. My brother left the house, got on his horse, and went to the police station in Catillo that was three kilometers away. My cousin, who had been at the house, accompanied him. He waited for Ruperto outside the police station and, after a while, a policeman came out, gave him my brother's spurs, and told my cousin to take the horse home because my brother had been detained for interrogation. When his two sons heard the news, they went to the police station to try to see their father and find out the reason for this second detention. The son that had been imprisoned with him earlier became desperate, he knew what awaited his father again: more beatings, more torture, more interminable questioning so that he would confess to crimes he hadn't committed and name people who could give more answers during the interrogations. When they arrived at the police station in Catillo they were told that he had already been taken to Parral. They called the jail in Parral but the police there didn't have information about my father either. They went home. . . they always say that that was one of the longest nights of their life, not knowing if the next day they would be told that my father was dead, like so many others who hadn't survived the secret interrogations.

The following day, they went to the jail in Parral and were told that my brother had arrived there and then had been sent to Linares. They looked for him at the jail in Linares, but his name didn't appear on any of the lists of prisoners there either. We found out afterwards that they had taken him to Colonia Dignidad. Apparently, the same night of his arrest, a truck took prisoners into

Colonia Dignidad, and we suspect that our brother was among them. No one knows what happened to the five people who were arrested the night they imprisoned my brother. It is possible that he spent some time in the jail at Linares (like we were told by another political prisoner who had been released), or perhaps they executed him after a few days. We will never know the truth. Sometimes I think that he is still alive among the prisoners in the Nazi jails of Colonia Dignidad. Unfortunately, even though it's in our own country, we will never be able to find out what goes on in that prison or what happened there during the years of the dictatorship. I have always thought that we committed a grave error when we allowed German Nazis to immigrate to our country and form their own colony on our soil. I knew that, some day, they would repeat their crimes in other parts of the world — I just hoped that it wouldn't be in my country. During the days and months after the military coup, people could see army trucks going into the colony. Most of the time, the trucks came from the detention centers and public prisons in the south. A lot of the prisoners who were tortured describe tortures identical to those the Jews suffered during the Hitler period. History repeated itself in our country, under our own noses, and no one said anything.

After my brother's second arrest, my sister-in-law began taking legal steps in the south and I immediately did everything I could from Santiago. We began by seeking help from the Pro-Peace Committee and gave them our testimonies about my brother's disappearance. My sister-in-law, Ruperto's wife, was ill. When she

arrived in Santiago, she had to go immediately to the hospital and they performed an emergency operation. She had Lupus, and that illness was aggravated by the difficult life that she had after the disappearance of her husband. I firmly believe that your health worsens when you no longer wish to fight the disease. I think that she wanted to die before having to accept my brother's death and disappearance. After being repeatedly released and re-admitted to the hospital for complications from Lupus, my sister-in-law let herself die because, like I said, she wasn't able to live any longer with the disappearance of her husband. Sadness kills, this terrible grief of not knowing what happened to our loved ones kills us, slowly, day by day. Some people die spiritually and others die physically, too. In the case of my sister-in-law, the poor thing wasn't capable of surviving spiritually or physically. I couldn't understand her, I couldn't accept that she would really be dying while she still had some life in her — I got angry with her and told her that she had to keep on living for her children, for us. I kept telling her that even if the dictatorship took her husband, she couldn't let the dictatorship slowly kill her, too. I wanted her to keep living and fighting with me to find Ruperto and to help our country return to democracy. At that time I didn't understand. Now after almost fifteen years I understand her more than ever because I am also dying. I have lung cancer and I only have a few more months to live. The difference is that my sister-in-law accepted death because she wanted to be reunited with her husband whereas I struggle against death because I think, even if there might be only a 1 percent chance

that my brother is alive, I have to find him, I can't die without finding him, or at least knowing where he is and what happened to him. If there is still some justice in this country, my dream is to see that justice flourish again before I die — and if there is divine justice, I want it to leave me in this life until I can find my brother. I have seen so many compañeras die since we began searching for our disappeared relatives. Because of that, I am aware that my day is coming, but I don't want death to take me before I have an answer, like it took so many of us: mothers who didn't know what happened to their children, wives who never found their husbands, sisters before they found their brothers, and children who never found their parents. I refuse to accept that double defeat. I know that none of us has been able to survive cancer — it's strange to think that so many compañeras have died from that disease — but if I don't overcome it, I want to be given me enough extra time to find my brother, to find out the truth and see justice done.

After my sister-in-law died, her sons and I continued the search for my brother. I went to the Pro-Peace Committee again and joined the women of the Association of the Detained-Disappeared. From the beginning, they helped me a lot. During those first years, some of the *desaparecidos* began to appear in concentration camps in the south and north of the country. During that period, we women separated ourselves into groups. Some were organized to search for disappeared family members while others joined together to help relatives who were political prisoners of the military regime. My group wanted to find them, other groups wanted to free them,

but we all worked together. We received help from women's groups in a lot of other countries throughout the world. We ourselves began to travel in the 1980s to voice our denouncements in other countries, and that strengthened our group and our cause. I personally organized women into a folkloric group — I was the first director of the group. I began to write songs and to put other compañera's lyrics to music. I believe that helped us a lot. It kept our spirits up and confirmed us to our people by expressing our pain through traditional songs and dances. We sang our sadness and our agonizing search. We also danced, but each of us danced alone to show people that our partners were not with us, that the regime had stolen them from our sides.

The Catholic Church helped us a lot, but other churches also showed solidarity and were very supportive during our difficult times. The Vicariate was the center where we all went in search of resources and to find out how to confront our crisis. We had never experienced a dictatorship. Chile had always been a democratic country where violence didn't take place and we didn't know about torture, disappearance or concentration camps. The Catholic Church also helped us to organize as a legal entity. We women used to have a secondary role in political activities. But after the coup, we realized that we could no longer be spectators: we would have to play a major role in the struggle against the abuses of the dictatorship and in the search for our disappeared relatives. I believe that something similar happened to the role of the Catholic Church in our country and the rest of the continent — and even in the rest of the world. It went

from being a traditional church to a church that tried to defend human dignity and fight for human rights.

I always thought that I would find my brother, I never lost hope. I believed that people like him would be set free after they were proved innocent. My brother was not officially involved with any political party. He was a farmer. He was a justice of the peace. He studied chemical engineering but always liked farming, so he decided to go live in the country. He dedicated his life to helping the campesino. When he realized the tremendous abuses perpetrated by the landowners and the Germans in Colonia Dignidad, he initiated his fight and committed himself to the farmworker. The Germans took control of our lands, exploited the agricultural worker, and didn't respect our laws. We have to remember that many of the Germans who came to live in southern Chile during the 1950s, specifically those in the so-called "Colonia Dignidad," were Nazis who escaped from German justice, and brought with them the mentality of a "superior race." In their colony and areas they could control, they maintained their same political and social values. When they arrived in the south, they found a large percentage of illiterate people, workers who didn't know their rights, who needed to work for whatever miserable wage they could get paid, and who saw themselves obliged to accept inhumane working conditions. My brother dedicated himself to helping them defend their rights and to fight for better living conditions, and because of that the German leaders fought him. My brother did his best to defend the rights of our people. The Germans not only took control of our lands but also closed off complete

areas where no one could get in to organize workers or even transport agricultural products from one place to another. They closed our own streets to us! During president Eduardo Frei's administration, a great effort was made to maintain dialogue with the Germans, but that didn't achieve anything. My brother was one of the best-known leaders of the campesinos of that region. The campesinos didn't even have the simple right to cross the street to get to the farmland where they had to work, the Germans closed the area to traffic. We couldn't believe that in our country we would be treated like foreigners and, above all, that the inhumane treatment would come from the same ones who years earlier had been guilty of the cruelest tortures and assassinations in Europe. It seems that mankind isn't capable of learning from any of the experiences that we have lived throughout history. Those were the abuses that my brother tried to prevent by organizing the campesinos in the south.

The terrible thing about this situation is that, in the Association, we thought when General Pinochet's dictatorship fell, we would finally find out where the disappeared were. But democracy returned and no one said anything. Those guilty were not tried and the criminals walk around free on the soil that covers the corpses of the tortured. Sometimes the rage kills me when I read in the newspapers that soldiers guilty of disappearances have been promoted to a higher position in the Chilean military. No one has been prosecuted in our country for the crimes committed during the dictatorship. In our town of Parral, where more people died and disappeared in terms of percentage of population, nothing has hap-

pened with the return of democracy. All the trucks that took people into the territories of Colonia Dignidad. . . no one has explained them. No one tackled that problem. Up until now, no one has investigated what happened in Colonia Diginidad during the dictatorship or what is happening there now with the tortures and political prisoners.

Now my children are grown. One lives in Portugal — still in exile — and the other lives in Chile. They built me a little house in Catillo so that I could return to my region, but when construction began so did the threats from the Germans. I will surely never be able to live in that little house, because my denouncements of injustice can never be silenced, and I will continue seeking reasons for my brother's disappearance. I feel tremendously powerless because I can't send my message to other corners of the world. I want people to know not only what happened in my country in 1973, but also what keeps happening wherever criminals are protected and the legal system doesn't defend the victims of political abuses.

I don't know exactly how much longer I'll live, but every day I have I will keep fighting to learn the truth about the *desaparecidos*. I pray to God that the young people in my country and throughout the world understand that to truly live, you must live with social commitment: individuals must unite in a collective effort so that humans may eternally live free.

(Gala Torres spoke these last words with great difficulty because of her cough. The last time I saw her, she had lost that sparkle in her eyes. . . those eyes that sometimes

spoke without her uttering a word. She gave one more concert, with remarkable effort, and sang her favorite songs about her dream of freedom. A short while later, cancer ended her struggle. Gala died in Santiago without ever having returned to her beloved Parral.)

* * * *

(I often heard Gala perform the following songs. Even shortly before her death, her voice could move an audience with the powerful messages conveyed by these lyrics.)

Song of Hope

I shall plant a rosebush.
As long as you are gone,
I will patiently care for it
A vile man came and told me
Until I can cut
The roses that you love
When I see you coming.

Chorus:

Give me your hand, María,
You take mine, Rosaura.
Give your hand to Raquel,
There can't be a Chilean
We will affirm our hope.

I shall weave a blanket.
Large enough for my husband
So that it can protect him
There, where he's kept from me
By some men of ice
Who are killing him with cold. (Chorus)

It's a very sad state,
Everyone ought to know,
The fate of a woman
Who doesn't understand why
Whenever I ask about you
They send me to prison. (Chorus)

What has become of my husband,
 Ay, what has become of my sons.
A vile man came and told me
 That I should just forget them.
 The one who gave me this advice
 Has a rotten heart. (Chorus)

 From all of you here
 I shall take my leave,
Day after day
 We fight for those missing,
There can't be a Chilean
 Who doesn't care. (Chorus)

I Name You Freedom

(In this song you are,
they are, I am. . .
all of us who now suffer,
who now fight, who will tomorrow
breathe the air of freedom together.

Do not be faint-hearted in your search for
that answer,
until we find out what happened to them.)

For the jailed bird,
for the fish in the aquarium,
for my friend who is in prison
Because he said what he thinks.

For the uprooted flowers,
for the crushed grass,
for the pruned trees,
for the tortured bodies,

I name you Freedom.

For the clenched teeth,
for the suppressed rage,
for the lump in our throat,
for the mouths that don't sing.

For the secret kiss,
for the censored verse,

for the exiled youth,
for the forbidden names,

I name you Freedom.

For the persecuted idea,
 for the blows received,
for the one who can't withstand,
for those who hide.

For the fear they have of you,
 for the surveillance,
 for the way they attack you,
 for your children whom they kill.

 I name you Freedom.

 For the invaded lands,
 for the conquered towns,
for the surrendered people,
for the exploited men.

For the dead in the inferno,
 for the executed innocent,
 for the assassinated hero,
 for the extinguished flames,

 I name you Freedom.

Chorus:

I name you on behalf of all,
by your true name,
I name you in darkness,
when no on sees me.
I write your name
on the walls of my city,
your true name,
your name and other names
that I do not name for fear.

For those for whom we search,
for the guilty silence,
for the answer denied,
for the life we love,
for the wilted rose,
for the wounded son,
for the struggle that never ends,
for the disappeared,

I name you Freedom.

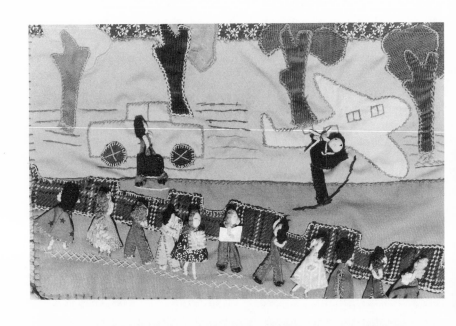

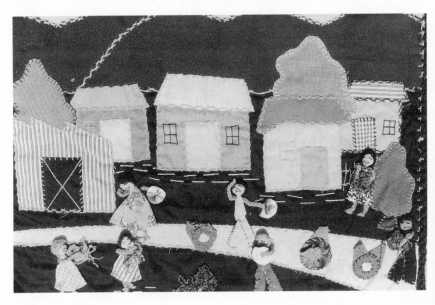

NEITHER PARDON NOR OBLIVION, ONLY JUSTICE: TESTIMONY OF VICTORIA DIAZ CARO, ARPILLERISTA AND MEMBER OF THE FOLKLORIC GROUP

My name is Victoria Díaz Caro. I am the daughter of Victor Díaz López, who was arrested and disappeared on May 12, 1976.

My name is Victoria Díaz Caro and my father, Victor Díaz López, is one of the *desaparecidos*. My mother, my sister, my brother, and I began our search the moment we found out that they had arrested our father. The year he disappeared, I was 25 years old and my younger brother was 16.

The day before the military coup of September 11, my father was talking with all of us at home and he told us that he had a terrible foreboding that something was going to happen in Chile. I've never been able to forget that papa told us that if his presentiments were real--if our country suffered a military coup — it would be at least 50 years before we Chileans could recover, that is, recuperate the paths opened by the Popular Unity during our time (the 1970s). My father had always distinguished himself by his unconditional love of our country, for the people of our country — he always inculcated in us that there wasn't anything more beautiful and divine than to give

your life for your people. My father went into hiding the same day as the coup, on September 11, 1973. At that time he had been the Undersecretary General of the Communist Party for a year-and-a-half, and he was also the national advisor for the Central Workers Confederation. As I was saying, the same day of the coup my father left home along with my 16-year-old brother, and went into hiding.

I will never forget the sadness I felt when I saw them leaving home, sneaking away holding a very small bag, carrying only what is necessary for survival. The two men of our household, the ones who supported our family, were now leaving at night, fugitives, their only sin trying to help their people have a better future. A few days later my little brother returned home. My father thought that we needed him and at the same time believed that soldiers weren't capable of arresting a child.

About 15 days went by and no police had appeared at our house looking for my father. . . the whole family calmed down, including my father with whom we communicated when we could. We had prepared ourselves and we had prepared the house. We burned my father's small library and all the books that we believed were compromising, among them the books that I had used when I studied in the Soviet Union. With my sister's help, we also threw a lot of the books in the river — we were afraid that they would arrest us for having books that talked about leftist ideas or were by compromising authors. The saddest thing is that before throwing the books in the river or burning them, we went to the houses of our friends and relatives with suitcases full of

books and begged them to keep some of the most important ones, because we knew that some were editions that we could never find again. It was impossible, so many people were already filled with fear. Hundreds and hundreds of pages burned or floating in the river, books lost forever. Terribly desperate to save some of our books, we put them in bags and buried them hoping that some day, when freedom returned to our country, the books could be put back on the shelves and all the young people would have the opportunity to read them, just as we had read them. Unfortunately, sometimes the people that had helped us to bury the books moved away. . . or the tremendous humidity that comes in the winter destroyed the books. We never found out where the books ended up, we didn't even find out if some were saved even when democracy returned after 17 years.

As I was saying, my father went into hiding in 1973. For almost three years we occasionally heard about him through friends or members of the Party, but in 1976 the notices stopped. We thought that a few years would pass and we would find him again. We stopped getting news about him and, then, my family began to be followed everywhere we went, and they followed my sister, my brother, and me individually. They watched our house day and night. We had to get used to being observed — it was like living in an aquarium. They also took photographs of us leaving and entering the house at different times of day. Our lives changed forever. I left my studies, as did many other university students, because they cancelled my matriculation and I couldn't return to the university. My sister had to leave her program, too.

She was finishing the education program in German, she was going to be a teacher. My younger brother was in high school. They followed him often and we were all afraid that they would arrest him. The secret service started to ask our neighbors personal questions about our brother. They spent hours following my brother wherever he went. After a time of living in constant desperation, my mother decided to send him to another country. We had already lost contact with my father in 1976, my poor mother wasn't able to risk the security of her son, too.

A while later, a lady that lived nearby came to our house and gave us the terrible news: a report had arrived that contained the information that our father had been arrested by the military secret service. I received the news first because it was a winter day on which my mother and sister were in bed with colds. I will never forget it. I remember that Mrs. Sara had to help me sit down and brought me a glass of water to drink. I clearly imagined that that was the end for my poor father. I went upstairs to my mother's bedroom and gave her the terrible news. It was May 12, 1976. They arrested him in the suburb La Reina. They took him from 279 Horizonte Street where he had been living in hiding, unable to see his own family for three years. They took him from that house at two o'clock in the morning. The house where he had been hidden was the home of Jorge Canto and his family. He told us that he saw my father leaving after the arrest with the guards who took him away. Twenty-five agents dressed as civil guards arrived, forcefully entered the house, and separated the family into different rooms.

They very cautiously searched all the rooms of the house and finally, when the civil guards were already leaving, they decided to go through a little room in the basement that they had missed and there he was in bed, my poor father. I still think about the tremendous desperation my father must have felt when he heard the children crying and the men walking through the house searching like crazy for him. Those must have been frightening minutes, seconds, of trying to cling to life. I'm sure that someone turned him in. He wasn't a religious man, but who knows what went through his mind at that moment. He must have thought about his wife, his mother, and felt sad that he might never again see his children. Jorge told us that when they entered and saw my father in that room, in bed, they made him get up and walk. Our father limped, that was the proof that they needed to know that he was the one they were looking for: Victor López was identified at that moment. Jorge tried to defend him, explaining that they were dealing with an old, sick man and, please, would they leave him in peace. But they already knew that one of the party leaders for whom they were searching had had a hip operation — now they had certainly found him. My father's friend, Jorge Canto, had helped my father to hide and had even helped him change his name. His new name was José Santos Rodríguez Retamales. All those years he had lived in hiding inside the house, without even going out to the garden so that not even the neighbors saw him. He never went out or even talked on the telephone in three years, until that morning when they found him. We think that someone in the neighborhood suspected that they had

someone hidden inside that house and they denounced him. They took my father away after beating him, they were trying to get him to confess his active political participation in the Party. They mistreated him badly. They say that my father didn't talk until after they took him from the house. They didn't let him get dressed, they took him from the house wearing only pajamas and shoes. He didn't complain or talk. They took him away in bad physical condition.

They didn't take away anyone from the Canto family that morning. But later they had to emigrate to France. The morning of the arrest, Jorge had to sign papers that said the prisoner was taken to "Cuatro Alamos." One of the men made a phone call before leaving and said, "Chief, we've got him now. . . now you know that when we work together we can get better results." A little while after they took my father away, someone called Jorge's house and asked him if everything was going well at home. The person never identified himself. He only asked for Jorge Canto and asked if everyone was well. In that instant, our friend knew that they had identified him and his family, and that their hours of freedom were numbered. That same morning at six, Jorge and his family secretly left home to seek refuge at the French Embassy in Chile. Although Jorge's vehicle was being closely followed, he and his family managed to arrive safely to the embassy. Jorge was able to emigrate to France, saving his life and that of his family, and from there they sent a statement explaining what had happened to our father in their house. Only then did we know, for sure, that our father had been arrested. We got the infor-

mation exactly four days after the arrest. The whole family became despondent because we realized that, surely, he had already spent four days of being tortured in secret service chambers. However, at that time we didn't know the conditions of interrogation of the detained like we know now. We thought they would torture him for awhile and then, when our father proved himself innocent of whatever civil or criminal charge, they would set him free. We never dreamed that belonging to a leftist party could be considered a crime punishable by death. We had faith that justice, which had always been respected in our country, would triumph and we would have our father with us again. Over time, we found out that from the investigations office he went to Villa Grimaldi and afterwards they took him to Colonia Dignidad.

Starting at a very young age, we were taught how difficult it was to fight for a political cause. Our father was always both a leader in the worker's movement and a member of the Communist Party. We were raised seeing him leave "relegated" by regimes that didn't accept workers organizations or the freedom of individuals to belong to leftist political parties. But even though he was relegated, he was always set free and returned home to his family. My father was one of those many citizens who was relegated to Pisagua during the years that Chile wanted to exterminate leftist ideology, but in that epoch they set him free and he came back to his wife and children. He never stopped fighting for the working class and for justice for all the citizens of his country, whom he loved more than his own life.

One of the most difficult things for me, as the youngest daughter, was that at the beginning I wrongly thought that this arrest would again be temporary and that my father would be set free. I myself couldn't search for him with the rest of the family because we were all afraid that since I had studied in the Soviet Union, I would be the next one in the family to be arrested. I was desperate, waiting for hours at home without being able to do anything. I hadn't harmed anyone nor had I committed a crime, but I had to live as a prisoner of the collective panic that the dictatorship created, losing precious hours that I could have used to find my father.

At first, all the responsibility of my family fell on my poor younger brother. He had to go to the morgues, hoping not to find the body of his father among the hundreds of cadavers that appeared every day. He went to the jails, hospitals, detention centers. . . and found no answer, day after day. I believe, at that time, none of us was prepared to find my father a shattered man. I know that today, after so many years, we are prepared to receive anything — even if it's just his bones, so we can bury him in peace and know that he rests eternally, placed in the ground by the hands of his wife and children. My brother went to the center called 3 Alamos. Apparently, they had taken my father there the first days of his arrest, but after that he went to two more centers and from there we were never able to find out his final stop.

We then decided to seek help from the National Vicariate. In 1976, many families had already gone to seek protection and help from that organization. The attorney at the Vicariate recommended that we first

submit a denouncement of "alleged grievance" to find out if from that we could get some answers. After that, we began to file lawsuits with different lawyers. During those years, lawyers even came from France to see if they could find some clues that might help us in our search, but everything was in vain. I remember that in 1978, a delegation of workers even travelled from Italy to try to help with what was for them a source of inspiration for the world workers movement. We received letters of support from all over the world. On Radio Moscow they asked everyone to appeal for clemency for our father's life. A radio program started at that time called "Listen, Chile," and at night we were able to tune it in and, sometimes, we could find out things that were happening in our country, where all the press was censured and strictly controlled by the dictatorship.

In 1977, my sister risked herself and participated in the long strike at CEPAL, which lasted 10 days. I had been fired from my job and, at that time, I was trying to find some sort of work to help my family economically. During those years, it was almost impossible to find work if you'd lost your job for political reasons. No one wanted to compromise themselves by giving work to people who had had family members arrested. I'd find work that would last a few days: as a temporary secretary, day care worker, entry-level positions, whatever I could. During the day I worked and at night I tried to study. I studied technical drawing and architectural design. I studied to enable myself to find a good job but, more than anything, by being busy day and night I momentarily forgot the desperation of not knowing my father's fate as

well as the terrible anguish of being followed, the anxiety of not knowing who they will arrest next, the desperation of not knowing if my father would come back to us or if he was dead — even worse, not knowing if they were still torturing him.

At the end of 1977 my younger sister, my mother, and I decided to take a more active part in the search and the protests. We slowly began to lose our fear. We participated in the "50 Hour Strike" on December 29 that was organized beside the Church of Saint Francis, located in the center of Santiago. We sat down and asked for information from the government about the detained and disappeared people. They didn't give us an answer and the soldiers tried to break up our peaceful protest. My mother and sister were careful that I didn't appear much in public — above all, that I didn't participate in protest activities, because some of my father's arrested or disappeared compañeros had had their children arrested, too. As an example, the Cantero family had lost a daughter and a son after their father had been arrested. No one knows where the children ended up. But shortly afterwards, in 1979, we three participated in the "Chaining" at the National Congress. This protest made history. We women chained each other with thick chains to the metal fences of the Congress. After wrapping the chains around our body, we put locks on them and we didn't have the keys to open them. We were there for about three hours before the soldiers arrived to break the chains. I will never forget the bravery of all those women who risked everything, who knew that arrest meant torture and long, painful interrogation sessions. That day, they arrested us

and took us first to the tribunal of justice. . . they left us there from the morning until 11:30 that night. They interrogated us individually and none of the 63 women would admit that it had been a collective idea: we all repeated what we had agreed upon before, that the responsibility and the idea were individual. For example, I said that when I was passing by the Congress and saw the women chained up, I took a chain out of my purse and I joined them. All of us, without a single discrepancy, maintained absolute solidarity with the group so that they would never find out that we acted as a group, united by the strength of resistance. When we left the tribunals, the people--the general public that had followed us and now waited outside for us — began to sing, in a soft voice that slowly got louder, the national anthem of Chile. It was incredibly moving to hear that powerful chorus: "that the grave may be of the free or the sanctuary against oppression. . ." We wanted to demonstrate that in our country there was no individual freedom, that we didn't even have the protection of the laws passed by Congress during decades of independence. We wanted all Chileans and the entire world to realize the terrible suffering of a country that lived under a dictatorship where the Congress had been closed indefinitely. During the whole time we were chained, we women held photos of our disappeared sons, husbands, brothers and fathers, and we never stopped shouting, "Where are they? Where are they?" or repeating the names of our disappeared family members. It was quite moving to see that people, although panicked about being arrested, stopped in front of us and applauded. The cars and public transportation honked their horns and

waved the victory sign with their hands. That was extremely touching. As a result of the protest, they jailed us and we suffered terrible mistreatment for five interminable days. They put all 63 women in a cell containing nothing more than some mats — there weren't enough for half the women. They didn't even give us bedclothes so we could cover ourselves at night. Those days in jail were terrible. They interrogated us at all hours, asked about people we didn't know, and tried to oblige us to tell whose idea the chaining was, if we had help from other countries, and if in Chile there were people who had organized us. It was hard for them to believe that we were a group of women united only by the pain and desperation of having lost our loved ones. We weren't a political organization, nor foreigners, nor did we have violent goals. We wanted an answer to something simple, to the question that we have been asking for years: Where are they? Nothing else. After that public protest and those days in jail, I lost my last job. At the end of 1979, I decided to definitely join the Association of Families of the Detained-Disappeared. I had already belonged to the arpillerista workshop since 1977, and in 1978 I had also joined the women's Folkloric Group.

I began to make arpilleras because it seemed a good way to express my unhappiness, my pain for what my people, my country and my family were suffering. For me, the arpillera meant not only political resistance, but artistic expression as well. I believe that I am one of the few women of the group that was interested in the artistic value of the arpillera as a testimonial document of art. I like painting and drawing a lot, so the arpillera allowed

me to explore my artistic vein that I had always wanted to develop. It was the same with the folkloric group: it was like starting something I had always wanted to do. Ever since I was young, I sang in choruses. While in Moscow, I was part of a duo that performed songs of our continent at the university. When Gala, the founder of the folkloric group, asked me to join them, it was one of the happiest days of my life. I could continue the search for my father and all the other people who were arrested, I could awaken people through my protests so that they would again seek the path to democracy and, lastly, I could do it while creating art and promoting music as a message of freedom. When we began the folkloric group there were three women, as time went on we grew to thirty.

The history of the folkloric group has been very interesting. A lot of the pieces that we sing and dance, we wrote ourselves, and a lot of the others were adapted from popular music. "The Chaining Song," for example, we wrote during the five days we spent in jail after the chaining at the Congress. I remember that when we were in jail that first night, we conversed a little, determined to keep our spirits up, and we thought about things we ought to do so as not to get discouraged. The next day, Gala surreptitiously brought us together, and we began to write the song: "On the 18th of April, we sixty-three relatives went to chain ourselves in front of the tribunals." It took us hours, but now it is a song that remains as a living testimony to what our country experienced at that time. We noted the words on scraps of paper, and right there in the jail we began to sing. We sang it with so much love and passion that they didn't say anything.

They couldn't make us be quiet.

In 1979 — the year I lost my last job — I began to work for the Association and dedicate my life to the cause. I did secretarial work at first because a lot of women needed to submit statements and didn't know how to type. But I helped with whatever was needed, like all the other women of the group. I also began to work with international organizations that searched for people who had disappeared in other countries. Back then (1981), they were beginning to organize FEDEFAM[1] in Costa Rica to help all Latin America. I worked with other groups so our cause might be the cause of everyone who was suffering due to the disappearance or arrest of a loved ones.

The theme of my arpilleras was always current events. I made arpilleras about our protest in front of La Moneda, as well as the chaining, the terrible experience of my first hunger strike, and the infinity of things that were happening every day. The only arpillera that I have never been able to make is the one that should have been created in homage to my father. I can't make that arpillera, emotionally I have never had the strength to make it. Maybe, some day, when we find out my father's fate, then perhaps I will be able to make an arpillera dedicated exclusively to my father.

Now, after decades of making arpilleras and looking for my father, and as I remember the themes and ideas represented by these arpilleras, I understand what my life has been, as well as the lives of all those women during the Pinochet dictatorship. By now I would have been teaching for 20 years or, even better, I might have

been an artist. . . I would have had such a different life than the one I've led. I've worked without vacations, without rest, every minute I was needed. For a very long time I got sick from nerves and had to have psychiatric treatment and take a lot of medicine to be able to go on. One time I lost all desire to live, I thought that it was all over for me and my family. I went into such a terrible depression that I sincerely thought my life would end. Even now I continue with psychiatric treatment. I owe my life to these women who taught me that the most precious thing we have is life and that we have to respect it, defend it, and love it more than anything else. I remember that, during those months of terrible depression, Gala came to my house one day and said, "Victoria, today you have to get up and come with us. We're singing at the National Stadium, we need you." I couldn't say no, Gala was asking me and we were to sing in the very place where they held the first political prisoners on September 11, 1973. I got up and went with Gala to sing. Moments like that were the ones that finally brought back my desire to live and keep on fighting. I realized that even though, perhaps, I had lost my father, these women would be part of my family for the rest of my life.

We have lost so much in the years of the dictatorship. For women like my sister and I, we've set our personal lives aside and dedicated ourselves to find my father and to help all the families who were searching like us. We let pass the opportunity to find a husband, the love of a man, and the chance to have our own family. I would have liked to have been a mother, I would have liked to do so many things, but I always felt my duty was

to give my life to rediscover the path to liberty, not only for me but for all my people. Now when I look back I see the life that we lived: we didn't do anything else but work in the Association. We didn't have even the most minimum pleasures of going to a play, the movies, or any other thing that we always think is so common and easy to obtain. Truly, we never felt deprived of these things because, for us, the cause was a true call to total dedication. I grew up without religion, but through the years I found faith in God and, at times, I think that is what keeps me going today. Now I have devoted myself more calmly to my art, and I live a very different life than what I would have lived had there not been the dictatorship. . . little by little, I am returning to normalcy by giving myself to my art and continuing to help all the people I can. My mother needs me, she was very strong through the years but now is confined to a wheelchair. She has never lost her spirit and faith in life. My sister has a different personality, she's dedicated herself more to politics, and she has resigned herself to the idea that my father is dead. She works from 7:00 a.m. until all hours of the night. She wants to continue the political struggle, she has been the pillar of the family, and wants to dedicate her life to political organization.

My younger brother is another story. First, we sent him to Switzerland, because we feared for his life. From Switzerland he went to the Soviet Union and then to Cuba. In 1983 he returned to Chile. He began to study theater, and during that time university students had begun to revive the tradition of our country of political involvement. My brother began to participate in

university activities with his compañeros, they began to protest. Due to his political participation, they suspended my brother for six months. During that period he couldn't go near the university. All those injustices that he had suffered since the disappearance of my father made him begin to think about protesting, but not like us women: for him the only alternative was to respond to the brutal assaults and torture with violence. We women tried to follow the path of peace, he chose violence. Without our knowing it, he joined the Manuel Rodriguez Front. We didn't find out about his activities until the day of the assassination attempt against Pinochet — we saw on the news that one of the arrested was our brother. Then we realized that he had been involved in those groups. They arrested him in 1986. They tortured him and, once again, the women of the family suffered the consequences. They searched our home, and began anew to interrogate us and follow us all hours of the day and night. We again relived the tragedy of my father. It was terrifying to experience the same abuses. When they searched our house again, they took all the books that we had managed to buy bit by bit, with great effort. This time they also took our awards and certificates, especially the ones I had received in Moscow.

My brother remained in jail, and was taken to the intelligence centers for interrogation and was brutally tortured. They hung him from his hands and feet, doubled over for hours, without anything to eat or drink. They applied electrodes to his genitals and different parts of his body. We weren't allowed to visit him. When we went to leave clean clothes for him, they gave us back the

clothes he was wearing the day of his arrest — they were stained with blood, and that terrified us because we thought, surely, this was just the beginning and then he'd disappear like my father. Feeling desperate, we got together with the mothers of the other young men who had been arrested. It was months of agony for the families. They moved him from the investigation center to a general prison where we were finally able to see him. It was a terrible blow to see him wasted, full of pain and suffering, defeated, bitter. At the end of that year he tried to commit suicide. I clearly remember that I was walking to the Association and, as I passed the kiosk on the corner by the house, I saw the headline: "Suicide Attempt at Prison." I stopped to read it and saw the photo of my little brother on the first page. I ran back to tell my mother and sister about the tragedy. With the help of a reporter girlfriend, we found out more details about his suicide attempt. Apparently, he had found out that they were going to turn him over to the CNI and he knew that he could not resist further torture. He had always said that he would prefer to kill himself rather than be tortured to death. He refused to give names or even to talk about his compañeros, and so they made his life in jail very difficult. From that moment, we began to visit him as often as possible, taking turns, to encourage him, telling him that there was hope that some day he would be free. We constantly told him that we needed him, that he had to withstand a little more. When my sister was able to travel outside of the country with FEDEFAM, she sought help from organizations that defended human rights to try to save our brother and other political pris-

oners. In jail, the young men held a hunger strike that lasted more than 30 days. I thought my brother wouldn't survive. We women organized and helped the prisoners in any way we could. They only drank water. They asked that the legal process be sped up, to be processed through the justice tribunals and not through the military prosecutor. They didn't listen to their requests, but they treated them better in jail. The international organizations helped to better the conditions of the political prisoners and stopped the torture a little. A short time later, we found out that our brother was among a group of prisoners that had escaped from jail. That was in 1990, the 30th of January. He was part of a group that dug a tunnel and escaped. That will go down in history as a slap to the face of the dictator, the fact that a group of men dug their way to freedom with their own hands. The dirt was taken from the tunnel and secretly placed in the ceiling crawlspace. They dug the tunnel with a spoon at night after everyone went to sleep. My brother did not participate in the digging, but prisoners from other political groups greatly admired him and offered him a place in the escape tunnel. Afterwards, when some of the escapees were captured, they confessed who were responsible for the escape, and they themselves said that my brother was one of the political prisoners who had least possibility of being freed alive so they helped him to escape. Later, we found out that my brother managed to leave Chile, he's now out of the country, and we know that he has a family, two children, and that he is well. We are asking that he be given a pardon so that some day he can return to his country and live with us again. We

don't have the freedom to talk to him whenever we want, for security reasons (for him and us). But we correspond and sometimes I receive phone calls in other places where we can talk for a few minutes.

Now, after almost 20 years, I feel that they want to destroy our last hope. They want us to pass the Final Point Law. They don't want to even grant us the possibility of recuperating the bones of our dead. We can't ever lose hope. I was an atheist like my father — although my mother was Catholic — but after having seen so many people respond to the terrible abuses with love, I have to believe that goodness is divine. To believe in God is a gift. Today I am able to say that after seeing so much suffering by so many innocent countrymen, I believe firmly in God. And with that faith, and until the day that I leave this world, I will continue looking for my father, a *desaparecido* since 1976.

[1] The Latin American Federation of Relatives of the Detained and Disappeared.

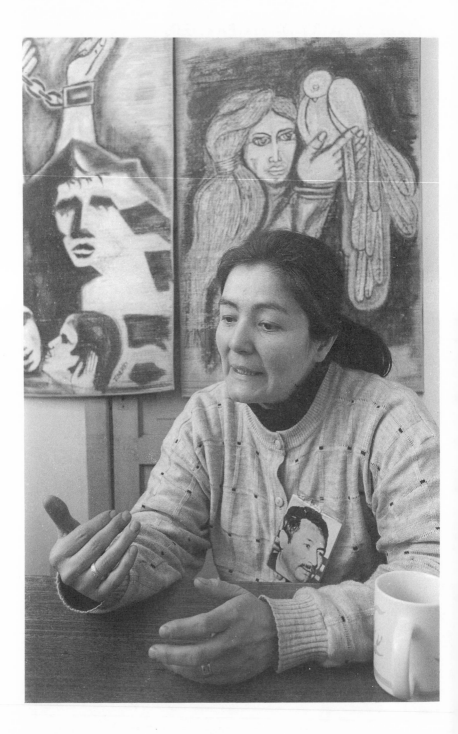

THE MEMORY OF MY FATHER, THE WOUND THAT WILL NOT HEAL: TESTIMONY OF VIVIANA DIAZ CARO, DIRECTOR OF THE ASSOCIATION OF FAMILIES OF THE DETAINED-DISAPPEARED

I am Viviana Díaz Caro, daughter of Víctor Díaz López, who was arrested and disappeared on May 12, 1976.

My father Víctor Manuel Díaz López was arrested and disappeared on May 12, 1976. Until September 11, 1973, my father was the Undersecretary General of the Chilean Communist Party and national director of the National Workers Organization. Due to the posts my father held, the armed forces and secret service agents began searching for him immediately after the coup. My father left home after the coup and lived in hiding until he was found and taken away. After his detention, we received information about our father through people who knew him and had helped while he was in hiding. During his twenty-six months of "voluntary confinement," everything was relatively quiet. We hoped that things would calm down and he'd come back home. All of us expected the persecution of our family, the searches, and other abuses would also ease up as the months went by. We all changed our lives thinking it would be temporary. Our children even left school. . . everything was in

a state of limbo.

They found my father on May 12 in a house in the Las Condes neighborhood. Jorge Canto was an engineer, and his wife worked for an international organization. More than twenty-five people arrived to search his house. They physically mistreated my father. They got to the house at 2:00 in the morning and, after hitting him repeatedly, they took my father away at 4:30 a.m. People who witnessed his arrest testified that he was almost unconscious when they took him away, and still in his pajamas. The couple who gave him asylum in their house had to leave the country because their whole family was in danger. We didn't know these people, but we found out about them after they left the country. They wrote us about the arrest and the brutal treatment given to our father. Our father was arrested under another name because when he went into hiding he changed his name, so they must have had very detailed information to find him. They beat him a lot in the beginning to get him to confess his identity. They also asked for names of other people who could be used to locate more wanted men.

After the arrest, we started to look for our father the same day we learned what had happened. The first thing we did was go to the National Vicariate — because that organization gave legal aid to relatives of detained and disappeared people — to find out what steps to take. We first submitted a petition for protection on May 14th. At that moment we began a new phase in our lives. The search was hard for us because none of us knew exactly what to do, we didn't know where to go to receive information about the detained. We didn't know where they

took people who were arrested. For my mother and the rest of us it was total chaos. We were always aware of the fact that my father would be arrested because he'd been an important member of the Communist Party. But we knew that our country had a strong tradition of justice and democracy, and we thought that in the eyes of the law my father would prove himself innocent of whatever crime and be set free. Even if they sent him someplace until the political situation stabilized in Chile, we believed we'd have the chance to visit him.

Soon we'd made the rounds like every other family that had detained/disappeared relatives. We began with the hospitals, jails, detention centers, the Legal and Medical Institute, etc. The answers were always the same: this person doesn't exist, he was never arrested, we don't have any record of this individual. In September 1976 a lot of people who had been held in Villa Grimaldi were set free. All were brutally tortured and then had been released without being found guilty of anything. A released female prisoner found us at the Vicariate. She said she had talked to one of my father's compañeras when the jailers at the detention center weren't watching. We knew Marta Ugarte, the compañera, very well. The woman told us they had burned Marta horribly with a blowtorch while interrogating her, they dislocated her wrists when they dragged her, and she was physically extremely weak. In this condition, Marta went to the woman and said: "If you go free, please look up my family. My name is Marta Ugarte. Or go to the Díaz Caro family and tell them I heard that ones like us who go to jail will never leave alive." The detained woman

who spoke with Marta was terrified about talking but did it anyway, and submitted a sworn statement about what she saw in jail and had heard from other political prisoners. She refused to go testify in court, and decided to stay away from everyone who asked for more information. All that happened in September, and in the beginning of October they found Marta Ugarte's body on the beach in Los Molles. Marta's body had been thrown from a helicopter into the ocean, and then it had washed up on shore. Her family identified her corpse. The authorities declared the murder a crime of passion.

After the testimony of that female prisoner, we stopped getting information about the fate of our father. But, that same October, DINA agents searched our house again and told us that if we kept looking for our father we would end up like he did. After that, the persecution became more intense and the attacks focused on our younger brother. My mother decided to take him out of school and sent him into exile. We three women stayed alone in Chile. After my brother's departure we joined the Association of Families of the Detained-Disappeared. It was hard to take that step because deep down we believed my father would someday be released. We always kept up with news about people who went into the detention centers, survived the torture, and later were set free — we even knew about people were released after being held incommunicado for more than nine months. The first years of our search, we were incredibly sad but also very optimistic because we always thought we'd find him alive.

After awhile, we submitted a denouncement for

kidnapping to the tribunals of justice and, some months after that, we submitted a criminal complaint against General Manuel Contreras Sepúlveda, the director of DINA. Later, we completely devoted ourselves to the Association. We started to participate in the hunger strikes, chainings, street protests — and we found out what it was like to be held in jails and police stations. We weren't afraid anymore, and we became armed with an infinite bravery. We knew we didn't have anything to lose if we fought, and our father's life was at stake. We learned that the military government offensively called us "the supposed families of the allegedly disappeared." The dictatorship always tried to discredit the fact that people had been detained, tortured, and later had disappeared.

Over the years, the Association initiated numerous national and international petitions asking for help in our search for victims of the dictatorship. In July 1977 our organization wrote an open letter to General Pinochet. We accused him of being responsible for the disappearance and detention of thousands of people and asked him to tell us the fate of all our tortured relatives who were in the concentration camps. Pinochet never responded to that letter or the hundreds of individual letters that so many daughters, mothers, wives, and sisters of political prisoners wrote. We wrote to the ministers of justice, the minister of the interior as well as the minister of foreign relations, the army commanders, and anyone who was in a position of power who could help us find out about the fate of the prisoners and disappeared.

It's difficult for people who haven't lived our reality to understand the conditions we Chileans lived in

back then. We couldn't even go to the press because there hadn't been freedom of the press for many years. The newspapers, TV channels, and radio were controlled. The only radio station that gave us some news after the detention of our father was Radio Balmaceda but a little while later that was censored, too. Censorship went to extremes in our country. They only released news approved by the government — even the publishing houses only printed books that passed the dictatorship's censors. An attorney who in July 1976 defended one of the petitions for protection of our father, Mr. Eugenio Velasco, the following month was expelled from the country. Justice disappeared when the dictatorship took control. Not only was crime punished but also ideas. The people imprisoned, tortured, disappeared, and exiled from the country were people who committed the "crime" of belonging to leftist parties. In the specific case of our father it was his militancy in the Chilean Communist Party.

In the Association we did everything possible, we exhausted all means to find the *desaparecidos*. Our work extended to the rest of a Latin America that in the 1970s and 1980s saw dictatorships invade and violent attacks against human rights. Our group helped to form the Latin American Federation of the Association of the Families of Detained-Disappeared (FEDEFAM) in 1981, and our first congress held in San Jose, Costa Rica. A while later, in 1985, that organization was recognized by the United Nations as a governmental organization. That meant this new organization, FEDEFAM, allowed us to actively participate in the United Nations Commission

on Human Rights so we could denounce not only the disappearances and imprisonment but also the serious problem of torture. Chile held a special place in that commission because United Nations officials were sent to our country to visit detention centers who managed to receive information directly from tortured political prisoners. That helped to get us more support from international groups in our fight for justice. But sometimes not even people who testified were safe. In 1978, three of our compañeras traveled to Europe to testify at the commission about human rights, and the military government refused them entrance when they returned. The United States treated these women very well, and gave them refuge for eight months until they received authorization to enter Chile and again see their families and children.

The 17-day hunger strike of 1978 started a powerful movement so that bishops, with the mediation of the Catholic Church, began legal proceedings and, for the first time, they publicly released an official list of the detained and disappeared. That strike marked a milestone in our movement. After that came the publication *Where Are They?*, which was comprised of individual, documented cases of *desaparecidos*. As an introduction to the publication there is a declaration of commitment by Cardinal Raúl Silva Henríquez, who promises to investigate what had happened with the detained and disappeared in Chile. They managed to publish seven volumes of documented cases but the Church stopped publishing it after not receiving an answer from the government. That was a step backwards for our movement.

Judicial power in our country bears much of the responsibility for what happened during the dictatorship. They didn't know how to stay above the politics and didn't fulfill their duty, their responsibility to protect the rights of the citizens before the law. They didn't administer justice, they helped to silence the crimes and punish the innocent. They are directly responsible for all those lives that were lost in vain.

Our fight has followed a tremendously difficult path. In the beginning, we thought even if our father had been arrested, he was alive in some torture and detention camp. Up until 1980 we, like so many people, thought that our father was alive. But in 1980 we put together a conference where many experts met: doctors, lawyers, reporters, clergymen, and social workers. We talked about the possibility that prisoners who disappeared from concentration camps were still alive. We concluded then that they were certainly all dead, and now our search was for the bodies and to see justice served.

In December 1978, my family and other women in our organization suffered a terrible shock when they found the Ovens of Lonquén. In a place that can only be reached on foot--it's over six kilometers on a road that goes into the middle of the desert — they found fifteen buried bodies. Three were apparently buried alive, according to the results of the investigation, and the rest of the bodies had gunshot wounds and other types of physical torture. They covered the bodies with lime. After the bodies were discovered, the Association interviewed minister Adolfo Bañados to get more information. The investigation was very detailed. They found out that

the burials and executions were on October 7, 1973, almost a month after the coup. They found bits of paper in the victim's clothing and other identification that the executioners didn't take away before killing and burying them. They identified Mr. Sergio Maureira and his four sons, also Mr. René Astudillo with two of his sons, the Hernández Flores brothers, and four youngsters who weren't more than 17 years old and who were arrested in the Plaza of Maipo Island for walking outside after curfew. Witnesses to the incident of the young men finally testified years after having seen the crime because they had been afraid of ending up in the same condition. Through their testimony, they identified the policemen responsible for the execution but the amnesty law released them from any legal punishment. A group of anthropologists in our country worked hard and developed the means to determine the identity of corpses they've found in different places where groups of bodies or bones have appeared.

Other such sites have been discovered, for example Patio 29 in the general cemetery of Santiago. There was an area of the cemetery where a lot of graves were marked "NN," "No Name." In 1991 they excavated and discovered 126 skeletal remains. Fifteen of them were identified and were properly buried in March 1994 — of these seven were detained-disappeared and another seven were political executions. Now they're finishing up identifying another fifteen people. It's a slow method, costly and difficult, so we haven't gotten very far. Of the 1,100 cases that our group has denounced as *desaparecidos*, only 86 have been cleared up. The cleared cases include fifteen

bodies found in common graves in Lonquén, nine from Laja and San Rosendo, and 18 from Mulchén. These were really remains of bodies like from the concentration camps in the times of Hitler. After our change of government, they discovered human remains in Paine, Nueva Imperial, Tocopilla, and Colina.

Another important revelation was when two countries published the List of the 119. In July 1975, they published a list of 119 Chileans who supposedly fought in Brazil and Argentina and had died in the confrontation. An investigation proved those people had never left Chile and it was all part of a conspiracy. That was discovered after they began "Operation Colombo" to find out more about the assassination of General Pratt in Argentina. Then they found out that the murdered people had never left the country and had been executed in Chile. The mothers in our organization who had children on that list never saw the bodies that supposedly were returned to our country.

Our Association continued with its work, and a lot of women died over the years without finding out the truth. It changed everyone's lives. The mothers sometimes assumed the role of head of household who had to maintain a family — emotionally and economically — and more important than the responsibility of raising children, they had to look for their disappeared husbands. A lot of women couldn't do it. Some died and left their small children orphaned, and others even ended up insane or left their children to raise themselves while the women searched for their father.

The Vicariate was fundamental in the help it gave

our organization. Now we're somewhere else, receiving aid from other churches, and we continue our work. Democracy is coming but we keep hoping to find out the fate of our disappeared relatives. We want a place where we can keep all the documents and testimonies of what happened in Chile during the dictatorship. We have to leave testimonies, a historical memory of the violence and dictatorship that changed our individual and national destinies forever. We have to leave that behind, like the house of Anne Frank, the silent example of the brutality committed against mankind. The *arpilleras* we made remain as a huge panel that will tell our individual histories along with the photos and stories of the disappeared for all the generations that come after us.

The transition to democracy would've had more support if we saw more results from the organization formed by our president Mr. Patricio Alwyn, the Truth and Reconciliation Commission. That commission didn't have authority to investigate, only to report. They couldn't investigate the activities of the military, they were very careful to protect the armed forces and not find anyone guilty. The commission released a report, and although the majority of the data came from our Association, it was important that the rest of the country find out about the detentions, torture and disappearances that really occurred in Chile. The negative part is they didn't find out who was responsible nor did they find out where we could find the bodies of the *desaparacidos*. For us, there was nothing new in the report, but it was a small triumph that the new government recognized what happened in our country. The truth published in that

document vindicated our disappeared fathers, sons, brothers, and husbands. Something very important for us was when the president asked us for forgiveness on behalf of all Chileans for what happened in our country. That small gesture verified our fight hadn't been totally in vain. But they don't tell us what we so much want to know: Where are they?

Later, another organization was created--the National Corporation of Reparations and Reconciliation — to give us economic remuneration to repair the damage. We were very offended that they put a price on our *desaparecidos*. We protested and explained we only wanted to know the truth. That new organization didn't have any authority either to investigate the facts but instead they wanted to solve the problem by giving money to the victims.

Now, currently, the army is pressuring to pass the Final Point Law so that all the abuses, crimes, and tortures will remain in the past. But in our legal code kidnapping is a permanent crime and as long as you don't find the victim the crime continues. We are supported by the law. We can't give in to the amnesty law Pinochet decreed in 1978 because the bodies haven't been found and a crime has been perpetrated.

Even now when they are building a monument in the general cemetery of Santiago in homage to the detained-disappeared and executed political prisoners, people who aren't aware of what really happened in our country say that we have to forget, that all this is like a wound that has to close so it will heal. Not a single parent who has a disappeared son can say that, no woman

who has a disappeared husband can say that, I will never say that I will forget what happened while I don't know where my father's remains are and how to recover those bones. There is no law that can protect those who know the truth about what happened or can help them live the rest of their lives with the complicity of silence. We women, more than anyone in the country, want the wound to close. But we want it to close and heal because of the truth, and from then on we'll look to the future with what we learned from our experiences, what we lived in the past. If it isn't our generation it will be others — perhaps our children's children or their children — who'll find the answers that all of us searched so hard for. You can't leave an open wound, but it won't close while it still oozes the blood of anguish of so many innocent people who were punished, whose only crime was having dreamed of a better future for all the citizens of their own country. No one has or will ever have the right to kill another human being for having a political idea different from the rest. Sooner or later we have to realize that you can kill people but ideas never die.

(Viviana Díaz is Victoria Díaz's sister. I included both testimonies because the lives of these women represents two different effects of the same experience. Viviana devoted herself to the Association of Families of the Detained-Disappeared in Chile, to group activities, and international causes, especially those that helped women throughout Latin America who had lost family members due to repressive regimes. Currently, she works with organizations that are dedicated to denouncing violations

and protecting human rights. She has participated in women's groups in Guatemala, Bolivia, Peru, El Salvador, Uruguay, Argentina, and Nicaragua among others. In contrast, Victoria used her art to denounce the abuses of the dictatorship and to help Chilean women find the disappeared. Viviana hardened herself and became a woman committed to social justice. She will give the rest of her life helping organizations that fight for human rights in Chile and the rest of Latin America. Her sister Victoria needs medication to ease her depression as well as constant therapy to continue from day to day.)

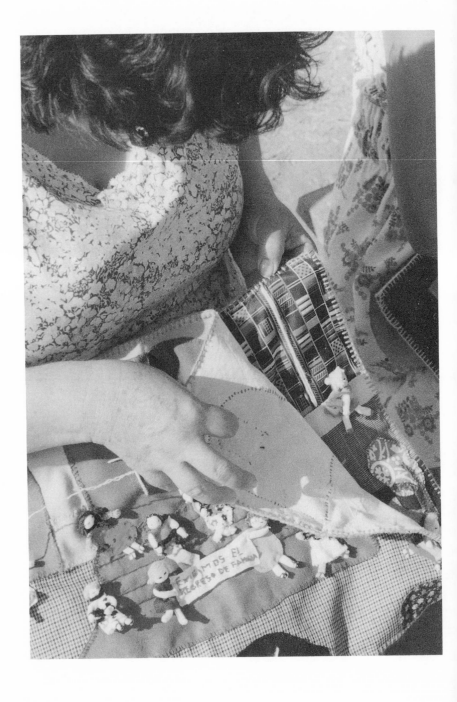

I BROUGHT THE ONLY SON OF A *DESAPARECIDO* INTO THIS WORLD: TESTIMONY OF MIREYA RIVERA VELIZ, ARPILLERISTA AND MEMBER OF THE FOLKLORIC TROUPE

My name is Mireya Rivera Veliz. My husband Plutarco Coussy Benavides was arrested and disappeared on September 27, 1973.

They took my husband away without any of us knowing what had happened. They took him to the Antuco holding center. He left home to go to work that morning and no one ever saw him again. He was living in the house by himself because we'd been told that the whole family was in danger. I left with the children to stay a while with my brother in Los Angeles, waiting for the first few months after the coup to go by. We thought if my husband hadn't broken the law, nobody could arrest him — and if they took him in, they'd interrogate him about his participation in the unions and workers organizations, and then they'd let him go. Since he was living alone at home we didn't find out about his detention until almost fifteen days after it happened, when I received an anonymous letter telling me someone saw them take my husband to the Antuco center. I immediately went home and spoke with the man who always

went to work with my husband. Then I found out what happened. He and my husband were on the bus going to work when the policemen got on, looked at the people and, when they identified my husband, they took him off the bus and took him away. My husband's friend told us he was sure it was a detention like what happened to all the worker leaders of the company he worked for, they were all prisoners. The union leaders were on lists of people who were wanted by the military, they were considered dangerous to the military regime because they took part in workers organizations. Right then, when we found out how they took him away, we began to search for him. First we went to the holding center and got proof that he'd been there, but from there he was taken to another detention center and no one knew exactly where he was.

Searching was hard for me. I had three little children and I was pregnant with our fourth baby when my husband disappeared. I went so many places, everywhere people told me I could get information about the prisoners, but I couldn't find out what happened to him. One day while I was standing in line outside the International Red Cross, a man showed me an article that came out in the newspaper on October 6, 1973. The article gave the names of a group of people who had been executed by firing squad and it also printed a list of wanted people. Two of the people supposedly shot showed up alive a little while later. Among the people wanted by the soldiers were my husband and several of his fellow employees who had already been arrested and disappeared-- none of these people have reappeared. Below the list it

said that if those people (the names on the list) didn't turn themselves in immediately, they would suffer the consequences. Now when I think back, I realize that was a way to justify the crime. The soldiers declared the men fugitives so they'd have a reason to murder them. But the cruel truth is they were most likely killed before those lists came out in the paper. The newspaper said those people were only wanted for questioning. My husband would have turned himself in, like a lot of other people, but the sad fact was even those who had turned themselves in disappeared.

My neighbors said my husband and one of his friends from work were accused of being part of Plan Z. Supposedly they were going to take part in destroying a hydroelectric plant that gave electricity to the entire region. That was something criminal and my husband would've never thought about doing it. For months, we lived with that rumor about him and the suspicion that he was hiding arms in the attic of our house. They never found anything in our house. They spied on us night and day. We never had a moment's peace. The first few days after the coup we heard explosions, and the lights would go out for hours and no one knew what was happening. There was no radio or TV, no communications to explain what was happening, so we were totally panicked because we didn't know what was going on at night. During those awful times in the dark, I closed myself in the bedroom with my children and prayed that no one attacked us or threw a bomb in the house. Sometimes I covered my ears to shut out the sound of the bullets we always heard, and at the same time I covered my children

in case a bullet came through the window. I was terrified and thought that one of those times in the dark, with no one to help me, with my three little girls, I could go into labor and have the baby prematurely.

Awhile later, I had to leave everything down south and come to live in a little house we had in Santiago. The house in the south belonged to the company my husband worked for, ENDESA, so when he disappeared they put me and my children out on the street. Before I moved out, I went and talked with my husband's boss to ask him to help me find my husband, if he had some information that could help me. The boss said he was very sorry, and told me that right after the coup the soldiers made him turn in a list of all employees who belonged to unions, and he had to obey orders. He also said all the workers who had supported President Allende were considered dangerous elements and possibly involved with Plan Z.[1] A lot of people who died after the coup and many others who were arrested were accused of being involved in the famous Plan Z that General Pinochet uncovered.

When my husband disappeared, our daughters were 10, 8, and 6 years old. I was expecting when he was disappeared, and during the rest of my pregnancy I went everywhere I could to find him. Sometimes I walked all day from one place to another without anything to eat. It was a miracle I didn't lose the baby or that my poor son wasn't born with problems after all those moments of agony I had during six months of frantic searching. Our baby was finally born and it was a boy, the son my husband used to dream about having when we were

together. A few days before our son was born, I heard the news that a boat was coming up from the south to the port at Valparaiso. I went by bus all night to get to Valparaiso thinking, before the baby came, I'd find my child's father with the political prisoners. While standing in line waiting for information about the names of the political prisoners coming by boat, I started to feel birth pains and contractions. Even though I tried to control it as best I could so I could find out any news before the baby came, our baby was born a few minutes later in a miserable hospital in the city. I had a baby in a place where I didn't know anyone. Our son came into the world without knowing where his father was. When I saw his sweet face I felt incredibly sad: in our son's little face I saw the face of my disappeared husband. Even if my husband was no longer there, I realized part of him was with us forever. I also knew, because of our situation when my son arrived, he wouldn't have the chance to grow up like other children because his mother was totally involved in an endless crusade to find his father. No one will ever understand what I felt when I gave birth to the son of my disappeared husband. I felt like I couldn't raise another child alone. . . I felt, just when the son we'd wanted for so long was born, it was the worst moment of my life. . . I was looking for his father, I didn't know if he was alive or dead. In the middle of my sadness, I thought they'd end up killing all five of us if things kept going so badly in my country. I had to hug that little defenseless body knowing he was conceived at a time when things were so vastly different than when he was born.

The worst thing I did to our baby was I refused to tell him the truth about what happened and so did everyone else in my family, and when he was seven years old someone at his school told him his father had been arrested and disappeared. It was awful for him because it was Father's Day when all the kids had to draw something as a present for their fathers. The next day I went with him to school, and explained the problem to the teacher and asked her to help my son. Now, after so many years, the rest of my children are married, and it's the one who didn't even know his father who helps me to look for the remains of my disappeared husband. Having a son alone was harder for me than for a woman who didn't depend so much on her husband. As soon as I got married, I stayed at home cleaning, cooking, and taking care of children. Even though we were poor, my husband believed he was responsible for the economic support of the family — I didn't know anything about money or anything outside of being a housewife. He was my husband, my companion, my protector. I didn't know how to do anything if he didn't help me. The tragedy of his arrest and disappearance changed me in a lot of ways.

I was always frantically looking for my husband and I didn't spend the time I should have with my children, and the one who suffered most was my boy who was born during the most terrible time in my life. I was working day and night to support them, and at the same time leaving most every day to go to the jails, courts, morgues, hospitals, and wherever they might give me some clue about the whereabouts of my husband. Days,

months, years went by and I refused to accept that I would never see him again. As time went by I tried even harder — I thought if I worked harder and searched faster, I'd find him. In order to support four children, I sewed clothes on my machine at home and sold them. My sister worked with me so we could earn a little more to buy food for the children. My oldest daughter was ten when her father disappeared, poor thing, and she became the other children's mother so I could go out and visit all the government offices or sew at night to support us.

When I first arrived in Santiago it was terrible for me and for the children, too. In 1974 everyone was afraid to talk, they were afraid of being detained, tortured, and interrogated. No one wanted to help me and no one trusted relatives of the detained or disappeared. All the people who hadn't been arrested, who hadn't suffered abuses from the dictatorship, didn't want to believe our stories. On the other hand we ourselves, families of the political prisoners or detained-disappeared, were afraid they'd take us away too, or innocent people would be arrested for helping us with our search. I personally felt so crushed that when people tried to get close to me, I didn't want to tell them my problems because I knew they wouldn't understand. The country was having such difficult times back then. Friends denounced friends, relatives turned in relatives, and no one trusted anybody else but themselves.

After spending months going anywhere they offered me a sign that my husband was alive, I started to look for legal help. I discovered that if I did all that legal paperwork, I'd feel more hopeful. Looking for legal aid

was how I went to the Pro-Peace Committee for the first time. It was one of the most special days in the hard times I was having. There, for the first time, I met other people who knew my pain and weren't afraid to listen to me. I talked with other women who were in the same situation as me and it gave me a feeling of solidarity, I realized I wasn't all alone in the fight. I found out then that all the other mothers, just like me, had given up their traditional roles and became workers so their children could eat, as well as fighters struggling for social justice to bring back their husbands.

During all these years of fighting I've participated in different activities of the Association of the Families of Detained-Disappeared. I'd never participated in political activities or been part of any organization before. In the beginning, in '73, '74, '75, I remember when I'd go to secret meetings and then return home alone at night — I was scared to death, I thought the soldiers would catch me and shoot me right there in the street. Being terrified so much without having anyone to confide in made me tough. I don't know if I'm not afraid anymore, like a lot of my compañeras, but I can say that now I'm able to go out in the street and protest, and I can face the police a lot better than I could've done twenty years ago. We women in the association organized a lot of protests and strikes so public opinion would help us, so the whole country would be aware of the *desaparecidos* and help us get the government to give us the information we needed. One protest I remember very well was the day Pinochet declared the law of "Presumed Death" for all the disappeared. We couldn't accept that and went into the street.

I remember there were about 250 women determined to stop them closing the cases of the disappeared. We went to downtown Santiago to walk as a group, and the police came and beat us brutally with their nightsticks until they were exhausted. They pulled my hair and hit me on the back and in my stomach. My stomach hurt so much that I didn't realize they'd pulled big clumps of hair out of my head. That time they arrested 80 women. But the law of "Presumed Death" wasn't passed. The pain wasn't for nothing.

Over the years I've made hundreds and hundreds of *arpilleras* that represent the terrible moments I've had searching for my husband, each one of them helped me remember him, to cry for him, and to keep waiting for him. I don't understand anything about art, for me the *arpilleras* are a form of communication with the world. If I knew how to say it in words I'd write it down. If I could paint, I'd paint it. It's a terrible pain and frustration for a woman not to know the fate of the man who was her companion for life, the father of her children. With this sadness and hopelessness in my life, the *arpilleras* were a special way to interpret my pain and at the same time to communicate it to others. My communication also had to be a denouncement, so people who saw my *arpilleras* would help free my country for my countrymen and my husband. I never believed in violence, and because of that my protest through the *arpilleras* has been silent, strong, desperate, full of unending tears. I can't count the long nights I spent making *arpilleras* and soaked the cloth because I was crying so much. Sometimes, on those nights when I made *arpilleras* until the

sun came up, I felt like, in a way, my husband was close to me. Maybe he really was with me then, I don't know. But those long nights making *arpilleras* and remembering my husband not only helped me emotionally, they also helped me economically. Every time I put together some *arpilleras*, I took them to the Vicariate and turned them in to be sold in the United States, Canada or France — those were the countries that helped us the most. The money I got for the *arpilleras* helped buy food for my children. After so many years of working at night, little my little I stopped sleeping. I would work almost the whole night sewing or making *arpilleras*, and the next day I couldn't sleep because I had to go do paperwork in so many agencies, so I wouldn't sleep at all. Now, after so many years, I've gotten used to it and I can only sleep two or three hours a night.

I've had such hard times over the years that I got very depressed. But I always said to myself I had to overcome the sadness and keep living for my children. The belief they'd give my husband back to me alive also helped me overcome the depression. I used to think, when I was alone and the children slept: "I can't let myself get depressed, I can't die, I have to be well when he comes home. . ." He was the only love of my life, his disappearance killed something deep inside me, it stripped me of any love I could've felt for another man.

For years I've also taken part in the association's folkloric troupe. I never thought in my life I'd be singing in public, much less dancing, but here with my compañeras I've learned so many things that I feel like another woman. Pain made me tough, the dictatorship

threw me into another life where, desperate, I had to work, with no preparation or schooling, to support my family all by myself. I've made *arpilleras*, I've sung, I did so many things that in the past I wouldn't have dreamed of doing, but I managed to keep my children alive, to feed, dress, and educate my children with dignity. But I recognize that without the help and dedication of the women in the Association, I wouldn't be here alive today telling you my story.

Now I'm old, my daughters are married, and my son still lives with me. I don't hope for anything out of life, I know my husband is dead and buried someplace maybe I'll never find. But even if they destroyed me emotionally, I'm going to use all the physical strength I've got left to find my husband's bones so I can give him a decent burial, and take him flowers, and feel close to him until my time comes. I don't have any hate, I don't want to take revenge on anyone — I only want to know the truth about my husband's fate. I hope to God that what happened here, in our dear Chile, never ever happens again. Now, after over twenty years, I promise myself I'll fight until my last day on earth so no child will come into the world when his father is detained and disappeared, or have to be born in the brutal, inhumane time of a criminal dictatorship.

[1] Before the military coup, Chilean leftist extremists were supposedly already developing "Plan Z" to overthrow the government.

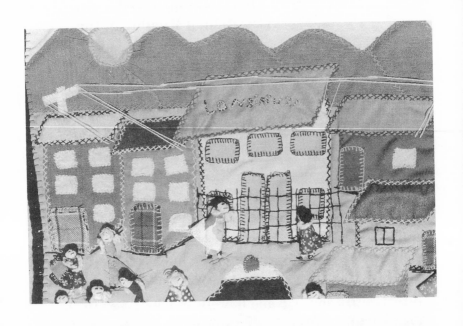

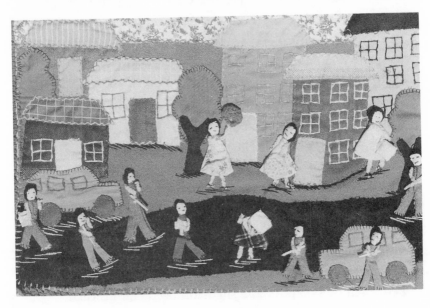

My Life's Song:
Testimony of Violeta Zuñiga Peralta, Member of the Association of Families of the Arrested-Disappeared Folkloric Group

I am Violeta Zuñiga Peralta, wife of Pedro Silva Bustos, who was arrested and disappeared on August 9, 1976.

My husband was arrested in the street, like so many people, without knowing exactly the reason for his arrest or who had arrested him. We, his family, found out afterwards that he had been arrested by the CNI (the investigative branch of the Pinochet's military government). At the time I was 40 years old and my husband was 39.

I didn't find out about his arrest right away. We were planning a trip to the south to visit relatives, when he told me that he had things to do and we had to postpone the trip. The day they arrested him I had left Santiago to visit my sister in Maipú. I came back around 8 o'clock at night, and it struck me as strange when I saw that he hadn't come home yet, because he always got home before I did and he would make dinner. That night the problem was, since he always arrived home before I did, I didn't have a key to the house and had to wait outside. I waited for an hour and then asked a neighbor if she knew where my husband might be. She told me that Pedro left at 4:00 p.m. and she hadn't seen him return

after that. The neighbor invited me to wait in her house because it was raining very hard. I waited a few hours and was growing anxious because it was so strange not knowing where he was so late at night.

I left my neighbor's house and went home — I forced open my back patio door and entered. I waited and lit the stove so that I wouldn't feel so cold sitting up at night. Hours passed and I became tremendously afraid thinking that, possibly, Pedro had been arrested. I walked desperately through the house looking for papers, diaries, magazines and books that could be compromising if the soldiers came to look for me. I also looked for photographs, taken of us together, and tore them up so that there would be no evidence, nothing that might be able to put him in danger if the damned soldiers came to search the house. Those terrible hours passed. . . three, four, until at six in the morning, while it was still dark, I left the house. As I was leaving the house I saw a man parked at the front passage who was watching me. We looked at each other, and I turned around and began to walk as fast as I could to Alameda Street. The man followed me at a distance. I arrived at Alameda and when I tried to take a bus, I realized that in the rush I hadn't brought any money. I went up to a young man and explained that I had left my purse in the house and asked him to loan me the money to pay the bus fare. I took the bus and I went to my sister's house in Maipú. When I arrived, I told them what had happened and they tried to calm me. They told me that, surely, Pedro hadn't been able to get home before curfew and had to spend the night outside. I remember how we all had to run to try to get

home before curfew during those years. I listened to the reasons they gave me, but I kept worrying about my husband. I spent the day with them and returned home that afternoon. I didn't find any message from Pedro. Then I began my search.

I visited all my relatives in Santiago and in Melipilla to find out if he was hidden in some house or if someone knew something about him. No one had seen him nor had anyone talked to him. Everyone helped me look for him. On one occasion he told me that if something happened, if some day he disappeared, I should go to look for him at the office of the Archbishop of Santiago on Cienfuegos Street, because I would certainly find him there. After three days I began to look for him in the hospitals and morgues in case he had had an accident. From there I went to look for him at the Archbishop's, and from there they told me I should go the Plaza of Arms, to the National Vicariate. By that time, Pro-Peace was dissolved and so we had to go directly to the Vicariate. I went there and they told me that they had to submit a petition of protection. The petition wasn't approved, so I began to send letters and ask for interviews with people in the ministry of the interior and other state organs that would be able to help me find him. Everyone told me that Pedro hadn't been arrested. No one could give me any information about him. But I kept searching, tirelessly. I was desperate not knowing how they took him away or where they had taken him.

After 14 years, one of his compañeros who worked in Talagante and who had been arrested came to talk to me. This compañero told me that he had been

looking for me for years to tell me that he had been held with Pedro in the Villa Grimaldi. It was very difficult to trust this man who suddenly appeared after so many years and who wanted to talk with me about my husband. I didn't understand his motives and, aside from that, I had found out that almost no one left Villa Grimaldi alive, so it was hard for me to believe this man. After talking with him for awhile, I asked him for exact information. I asked him, for instance, if he remembered what clothing Pedro was wearing. The man remembered Pedro's clothes and also told me that he managed to talk alone with Pedro one day. The man said that on Wednesdays they took them to interrogation sessions — now we know that they were really torture sessions, not interrogations. This man told me that on one of those days when they didn't take my husband to the session, he was able to talk with Pedro alone. Pedro told him that he had been arrested on a bus that was going to La Granja. My husband explained that they had followed him and, after arresting him on the bus, they took him in for interrogation and imprisonment at the Villa Grimaldi. The man told me that although Pedro had black eyes, showed signs of being struck on the face, and he had received physical punishment, he was still full of hope and didn't seem defeated.

Doubtless, Pedro was detained because he was a Secretary of the Communist Party. He was the Political Secretary of the Committee in Viña del Mar. After the coup we went to Antofagasta because we were afraid that in Viña they would capture him. From Antofagasta we decided to come to Santiago, also because of the fear that they would find us and take us prisoners.

Pedro and I had lived together since we were 16 years old, and we gave our lives to political causes. We never had children, we sacrificed everything to help people who needed us. Because of that, when I realized that they had take him prisoner and that he would be imprisoned for a long time, I despaired and began to help the Vicariate while I looked for him along with all the other women who had also lost family members. When I arrived at the Vicariate and met the rest of the women who fought to have their petitions of protection approved, I realized that I wasn't alone. I decided immediately to become a member of the group, the group made up of relatives of the *desaparecidos*.

At times I think it was unjust that they arrested him without me. But I believe that it was mostly because in 1973, when the military took over the government, I wasn't in Chile. I had gone to the Soviet Union in March of 1973. A month before returning to Chile the military coup occurred so I decided not to return immediately. Pedro told me to stay away, so I spent two desperate years far away without knowing how things were in Chile. The news that arrived in the Soviet Union was terrible -- I didn't know what had happened to Pedro, my family and the rest of my friends and associates. They were two terrible years of my life, emigrating from country to country trying to work to support myself. Towards the end of 1975 I returned to Chile, I returned afraid, but I couldn't stand it anymore, being far away from everything I loved so much. They offered to let me remain a political exile in a foreign country but, although I knew I would be in danger, I felt the terrible need to return to

my country and help my people.

I remember how difficult the return from exile was. From Italy I went to Germany, because from there I had passage to Chile. I will always remember what happened that night in the airport. When all the passengers were on the airplane, they announced that there was a bomb on the plane and all of us had to get off. The hours went by and I missed my connecting flight, so I had to stay in Germany. I was terribly afraid — maybe the bomb was meant to kill me. In those situations when the fear is intense, you always think the worst. It was horrible because I could get by in Italian but I didn't understand any German. During the day, I walked desperately through the streets and at night a slept in fits and bursts, thinking that someone would come looking for me.

After a few days I was able to take another flight and finally, one day in autumn at five o'clock in the morning, I returned to Chile. There was a thick fog and you could barely see anything through the window of the plane. I can't even begin to describe the overwhelming fear I felt when I left the plane. I didn't know what was going to happen to me upon my arrival. My relatives had told me that Pedro wouldn't be waiting for me in the airport because our meeting would be very dangerous — they would be able to follow him, or they could find out that I had returned from exile. When I arrived at the airport, I passed by the windows of the international police and they read all the entry stamps of the countries where I had spent the last few years. After stamping my passport a customs officer took me to an office and interrogated me. He asked me what date I had left Chile, what

were the reasons for my trip, how long I had been out of the country, and why I was now returning to Chile. While I answered his questions, through the glass I watched my family that was waiting for me outside the customs office. I remember how I was watching my sister and trying to smile to calm her down. The man began to ask me the same questions again to see if I would change my answers. He was mostly interested in why I had left Chile and why I was coming back. After an hour he let me leave the office. I left, hugged my family, we got in the car and tried to leave the airport as quickly as possible.

After a month back in Chile, one day while walking through Almirante Barroso Street, a yellow car approached me and some men opened the door and told me "get in immediately because we want to talk to you." I ignored them and began to run into the crowds trying to lose them — the car tried to follow me but as I turned a corner I was finally able to lose them. I ran like crazy until I got home, all the time thinking that they would capture me before I arrived home. A lot of things like that happened during the following months. The compañero who I was living with and I learned not to return home by the same route or take the same buses every day. If we noticed that we were being followed we crossed first to the other side of the street to lose them and then walked home. But we always took into account that they were following us and we couldn't leave them a trail or they would find out exactly where we lived.

At that time I was taking care of my sister's children, because it was hard to find work after returning

from exile. I remember that some weeks after they arrested Pedro, I was in my sister's house and a grey car with two men in the front seat went by. My sister looked through the window and called me, and the two of us, hidden, kept watching through the window. In the back seat of the car we saw my husband. We thought that they had come to look for me. But they didn't get out of the car, they slowly drove by the house several times and then left. She and I think now, after so many years have passed, that they were taking Pedro to the different places he had lived before his arrest, in order to find out who else was involved with him. That was the last time we saw him — that had happened two months after his disappearance. It's ironic to think that on the day of his arrest, I begged him to accompany me to my sister's house in Maipú because the previous night I had dreamed that he had been arrested. He refused to listen to me. If he had gone with me that day, perhaps he'd still be alive and we would be together. But I was always having dreams like that. With that terrible desperation that you constantly have in your life, you always have those kinds of dreams and you wake up crazy with terror, but you keep on living.

After the arrest and disappearance of my husband, I tried to join the group of the families of *desaparecidos*, and it was very difficult for me. When you go to those groups where the women have experienced so much pain and suffering, you find that no one wants to confide in anyone. Everyone becomes suspicious. It was hard to tell my story, and it was difficult for the women to trust me and to dismiss the idea that I could be a spy of the mili-

tary regime who was looking for information about the group. Those were some very difficult weeks for me. I needed support and I found distrust. But, little by little, I found out that it was normal because there had been cases in which the government of General Pinochet had sent women to tell stories of *desaparecidos* so as to enter the group and get information about the women's activities. In some cases those women helped to arrest people who were in hiding. The situation of women was very complicated in those years. No one knew who was who. There were women who came to participate in the folkloric group who didn't know us, and who — we found out later — didn't have disappeared family members. One way for us to find that out was to see if these women had never used a legal petition of protection. Our lawyer called them and they began to distance themselves from us, and afterwards they didn't help with our group activities again. Another reason we discovered later was that some of these women weren't sent by the government, but rather the same economic desperation that we were suffering caused them to lie. They came to the group thinking that we received economic help from international organizations and that we earned money by means of our cause. It was sad to see that those poor women would do anything to survive and to support their children and unemployed husbands.

My first task in the group was to carry letters to the Diego Portales Building. These were letters that we wrote asking General Pinochet for clemency. We pleaded with them to help us find our loved ones. We wanted to know, if our family members were imprisoned, where

they were. We wanted the government to tell us in which cemetery they had been buried if they were dead. We wanted answers to our exasperating uncertainty. We sent a lot of letters to Mrs. Lucía Iriarte de Pinochet, the wife of General Pinochet, thinking that she, as a woman, mother, and wife would understand our pain. How wrong we were! That woman doesn't deserve to be called a wife. They never answered us and when they did it was to tell us that they didn't know anything about the *desaparecidos*. Some of these letters are in the library archives of the Vicariate.

When I began to work every day at the Committee, I was being followed almost daily. I also began to receive letters at home. For example, I received pretty Christmas cards that inside said that Pedro had been tortured, that they had killed him and thrown his body into the sea. I also got letters that told me if I paid a certain amount of money, they would release some of Pedro's personal effects to me that had been left when he had been arrested. Apparently, these were activities of the DINA, the government secret service, because other women who were followed by the secret service also received the same letters. I remember that I brought back an expensive Italian watch for Pedro, and they offered to return it to me if I gave them money at a certain meeting place somewhere in Santiago. In the letters they would indicate the place, day and time. They also asked for a fixed amount of money for the watch. I always gave the information to the attorneys at the Vicariate, and they advised me not to go to the appointments. The letters were always signed with the name "Commando." Later, I

found out the history of that signature. An agent of the government secret service had tried to disarm a bomb found near the Mapocho River, and died in the attempt. The military said that groups opposed to the government had killed him. From that time on, the secret service began to use that name to remind us of those who opposed Pinochet by referring to the death of the official. One of the most impressive things about these letters were the details they contained. So when they wrote me about Pedro's watch, they described it in detail, and they told me what exactly Pedro had in his wallet. They also threatened me: they told me that if I didn't show up for the appointment the same thing would happen to me that happened to my husband. I was constantly afraid. I hated to get home and see those men on the corner, the same thing happened when I left the house, they were always watching me. They all looked the same to me -- tall, with dark glasses and wearing suits. They were always well dressed.

I participated in the committee activities but I never made *arpilleras*. I took part in the folkloric group. I was one of the founding members of that group. I started with the group dancing the *cueca sola* in 1978. I remember that on March 8th of that year, I danced the *cueca sola* in public for the first time. I will remember that moment my whole life. It was at the Caupolicán Theater, we were celebrating International Woman's Day, and the theater was full of people who were struggling, as we were, for liberty. The group began with pieces that had sections that were sung and recited, and afterwards I began to dance. I have spent years now

singing and dancing to denounce the abuses of the military, and so that people will be aware that this can happen again. We have to commit ourselves to the fight for our ideals and to stop the abuses against human beings.

My life changed totally after the coup. I never married again. And since we never had children, I am totally alone now. Living alone with the tremendous anguish of not knowing where my husband is — it's terrible for me. I have nobody. I don't even have a grave where I can shed my tears for my dead Pedro, if he is dead. It's different when they give you a body to bury, then you can feel that the end has arrived for your loved one and you can start to heal the wounds of the loss. But when your partner disappears, it's so different than when someone dies. You spend the rest of your days looking and thinking that, one day, the person will appear, alive. You don't think about finding another person to marry. Everything revolves around the search and the next time you'll be with your husband.

My relationship with my whole family had changed too. At first it was because of fear. They were all afraid to associate with me thinking that I would compromise them and something would happen to them — and at the same time they felt sorry for me. I felt not only that I had lost my life-long companion but my family, too. And now, after so many years of struggle, my family says to me "what have you gotten out of all this, Violeta?" They're right. I haven't found Pedro, I don't have any children, and I live day to day without the economic means to support myself during my last years. Now there are times when I have to stay and eat with my

relatives because I don't have money for food. I have
spent years and years doing volunteer work, helping
other women and looking for my husband, I never
thought selfishly about my future. I gave my life to the
cause and now I have nothing.

I think that, maybe, now I feel more pain that
before, when I was young — I believe I have lost hope and
it's crushing me to live without it. When they found the
Ovens of Lonquén, it had a strong impact on me because
I realized that I would never, ever again be with Pedro. I
know that there are women who still have hope, I'm
happy for them, but for me that was the hardest moment
of truth. I thought, at that moment, if they found all
those corpses of people who were brutally assassinated,
there was no possibility that Pedro could be alive in any
prison in the country. It was very sad for me because I
had this idea that they would detain him for awhile and
then, later, they'd set him free. Never, ever did I think
that his parting was forever. Nor did I ever think that in
my own country we would find true concentration
camps.

Now that I read in the newspapers about the Final
Point Law, I realize how easy it is for people to forget
everything that happened. The best thing for them is to
put everything behind them and whoever has disap-
peared, disappeared. I don't agree either with the am-
nesty law. They ought to investigate what's happened,
they ought to find the guilty parties and punish them to
the fullest extent of the law. They are criminals like any
other criminal, it doesn't matter if they were military or
civilian. If they look, they'll find and punish those guilty,

maybe we'll be able to find the answers to our questions about the *desaparecidos*. We have to build a new country with a stable democracy.

Our message continues through our music. I hope that with our songs and dances, especially the *cueca sola*, people become aware of what we have experienced in Chile. Our silent protest and denouncement continues day after day with our songs and dances. All the songs speak of our problem which is, at the same time, the problem of a lot of people in our country. The *cueca*, especially for us, will always symbolize the loneliness of the woman who has lost her man to the military dictator-ship. Our national dance — that is always danced with a partner and represents the courtship between a man and a woman — became, with the military coup, another demonstration of the woman who alone continues search-ing for her disappeared companion.

The only thing left to say, now, is that, God willing, people will listen or read our words, our testimo-nies, and learn from our experiences. We gave our lives to defend liberty. We have had to be both mother and father for our children who lost their father, we have had to help mothers who lost their children, and even women like me who lost the only man in their life. We took a stand to denounce the abuses of the dictator and find answers as to the whereabouts of the *desaparecidos*. We've achieved the possible return of a democratic regime to Chile but we have a lot more to do. We have to ensure that the people are aware of the truth so that this horror doesn't happen ever again in Chile or in any other coun-try in the world.

(Another woman who listened to Violeta while we discussed her experiences told us at the end of the interview:

"I want to add that through the years there have been many heroic women, fighters like Violeta. But, as the years went by, I realized that she is the one who gave herself, heart and soul, to help the other women of the Association. The spiritual strength of this woman is admirable. Perhaps because she is alone, or maybe because she is stronger than other women, but it was Violeta who put everything aside to fight for the rights of those who have suffered political persecution. She never showed fear, never allowed herself to be arrested without resisting, and always squarely faced violence in order to defend the rest of the woman who were beaten. She worked daily, any way she could, in the Vicariate and in the Association of the Arrested-Disappeared. All our women and our country owe Violeta so much for the unconditional help that she gave during her whole adult life. It saddens us when we see her now, grown older and so alone. We have children and grandchildren, but I believe that Violeta's loneliness is a loneliness different than other women's. She will look at her past and will always feel that everyone who now walks free through the streets and cities of Chile received her life, and she will know that her loneliness is a loneliness full of people, like we who are here today, who are thankful for her love of justice and human rights.

Violeta Zuñiga refused to say anything else after her associate and friend of many years had spoken. She only said the no one could ever truly understand her loneliness

163

and pain. Afterwards, she cried silently for a few min-
utes, and then left the room in which we had met that
afternoon.)

— Santiago de Chile, January 1994

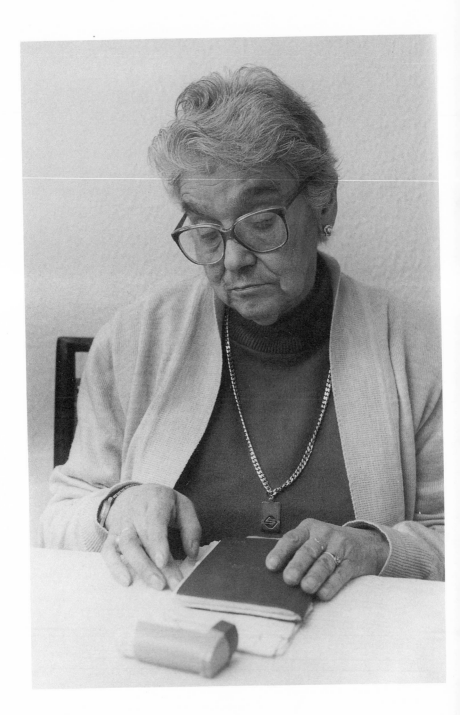

IN THE FOOTSTEPS OF MY SON: TESTIMONY OF DORIS MENICONI LORCA, ARPILLERISTA AND MEMBER OF THE FOLKLORIC GROUP OF THE FAMILIES OF THE DETAINED-DISAPPEARED

Doris Meniconi Lorca is the mother of Isidro Pizarro Meniconi, who was arrested and disappeared on November 19, 1974.

They detained my son at the Sixth Precinct after they took him from Joaquín Godoy Street, which is in the Egaña Plaza district. The policemen shot him when they arrested him, but he was alive — wounded, but alive. The policemen then turned him over to the DINA.

Before he was arrested, we knew he was in danger. He was living clandestinely because he had been warned that they were looking for him. We all believed that if he hadn't committed any crime, then they couldn't detain him. We always thought that justice would prevail in our country, even though democracy was dead. On the day of his detention, they announced on the television news that they had found my son and had arrested him. It was a terrible shock for the whole family at home. I believe deep down we all knew that day was coming, but it still came as a surprise, and we were sick at heart when we heard the news. It was a double surprise because, minutes after the broadcast, armed soldiers arrived at our house

with our son's identity card. I opened the door, panic-stricken, and shouted, "What's happening!" They told me, "We have detained your son for events that occurred a few days ago and we want information." They also said, "Don't worry about your son, nothing is going to happen to him." Then they told me they had orders to search our house. They came in and looked in every corner: through furniture, the bedrooms, the kitchen. They moved, searched, and destroyed everything. They didn't find anything that they could take as evidence. That was the search on the same day as our youngest son's arrest, November 19, 1974. It was really our second search, the second time we were shocked and hurt, faced the cruel reality of emotional and physical torture, and the possibility of death. My oldest son had been arrested on June 6, 1974. He was set free in 1976, beaten and tortured, but alive.

My whole family was persecuted right after the coup d'etat in 1973. My husband immediately lost his job, one of my daughters was also fired without cause, and another of our sons went into exile in Costa Rica to avoid detention. One of my daughters-in-law immediately sought asylum with her baby at the Venezuelan embassy. The rest of my family escaped to Switzerland. Today, all of my eight children live in Switzerland — I have six daughters and two sons. My husband couldn't bear any more and decided to go to Switzerland, too. He wants to live near his children and grandchildren. I decided to stay. It's hard and sad living alone, so far from my loved ones, but the hope of finding my disappeared son keeps me in Chile. If they killed him, I want to

168

know where he's buried so I can take those last flowers to him and see that his dear body rests in peace. But there is another part of me, as in all mothers, that believes if there is the slimmest chance that he's alive in some jail, I can't stop fighting to find him, looking in every corner of this country, wherever he may be. No one, no mother, father, or child, will ever be able to rest in peace without an answer to that persistent question: Where are they?

I remained in Chile and my humble little house has been transformed into a small international center. People from all over the world come seeking help to find their disappeared relatives, or to look for insights that my experience might offer them. Also, young people from other countries visit me as well as Chileans who knew my son. For me, these young men have a piece of my son in them. When his compañeros or friends come to my home and say, "I knew Pizarro" or "I went to high school with Pizarro," my heart fills with tenderness and I see my son in them. They know it and feel it, so they visit me constantly and, together, we remember my son's life.

Believing that my son was alive kept me alive for many years. I think, until a little while ago, I clung to an almost 10 percent possibility that he survived. But I have to accept reality. They detained him in 1974 and afterwards, in July 1975, they released a list of 119 prisoners — my son's name appeared on that list. I will never forget the mixture of pain and happiness that I felt when I read his name. My heart leapt with joy to know — yes! — someplace in Chile they had him detained alive, but at the same time I was overwhelmed by the brutal reality that my son was a prisoner, tortured, and maltreated like the

others who had fallen with him. I came up with the idea
that the list was the hope which I had to affirm in order
to draw strength to continue my fight for his freedom.

A prisoner who was held with my son was set free
in 1976 and gave testimony before the courts about what
he had seen. I interviewed him and he told me he had
met my son, that they had been together in jail. He told
me the last time he saw Pizarro, he had been in very bad
physical condition. This young man was in a cell with
twenty other prisoners. He explained that in the corner
of the cell was a bed, partially covered by a curtain, and
someone in the bed constantly moaned with pain and
didn't talk. One day at feeding time, he left the group
and went over to the bed to see if he could help that
person, perhaps offer him something to eat. He was
horrified at what he saw. My son lay on the bed with an
infected mouth that was covered with wounds, blood, and
pus. The young man offered him some food but my son
couldn't eat. The man cleaned his mouth as best he could
and asked what he could do for him. With great diffi-
culty, my son spoke to him and told him that he was
crushed inside. He explained that they had put a manhole
cover on top of him and then drove a truck over the
cover. My son made a great effort to continue speaking
and asked the young man to, please, not forget his name:
Vicente Pizarro Maniconni. He also said that his mother
was named Doris and she lived in the shantytown La
Palmilla. He asked him to look for me and to tell me that
he was alive. They kept talking until one of the guards
saw that he was talking to Pizarro, and then they took the
man from the cell. They immediately punished that

young man and they took my son from the bed that same afternoon. The man was returned to the cell after the punishment, but says that my son wasn't returned to that cell and no one could find out anything more about him. I think perhaps they took him to the hospital and saved him, or he died there in jail. According to the testimony of that man who saw my son that last time, there is a slim chance that my son is still alive. I am not going to let that hope die in me.

Back then, I also had the opportunity to speak with another prisoner who saw my son in the detention center "Venda Sexy." The officials claimed the center was a modern discotheque. It was always kept dark and they turned on loud music so that no one heard the screams of the people who were tortured while they were being interrogated. The man who spoke with me is an anthropologist, his last name is Padilla, and he even testified in writing that he saw my son injured. But he told me, personally, that my son had received gunshot wounds in the legs. He told me that my son had been arrested along with a young girl named Aída Vera, who had the nickname "La Gigi." After those testimonies I clung to the illusion that my son was in bad shape, but alive. I felt, as a mother, I couldn't let hope fade. . . I couldn't think that I didn't need to look for him. I kept going from jail to jail, from station to station. I visited hospitals, morgues, every place where they might have some information about the detained. Every day I made a new list of places. Sometimes I visited other women's sons in the jails to find out if they had some information that could help me in my search, but I got no results. My desperation grew

with the days and months. I felt if I hurried to find him, perhaps they would torture him less or that there would be a greater possibility of finding him alive.

My son was a campesino leader. The countryside was his passion ever since he was young. At a very early age, when he finished secondary school, he went to work in the country boxing tomatoes and cutting greenbeans. He matured and continued in agriculture, joining the farmworkers. Years later, because of his leadership skills and political ideals, he became one of the farmworkers' directors. He helped the campesinos with the most basic and necessary things, even with documents that needed to be well-written. He wrote petitions for managers and even requested seeds from CORA.[1] He constantly fought for the implementation of agrarian reform. He organized many campesino protests for better working conditions. When my son spoke of the changes that were needed in the country, he would always say: "Mamá, there are many injustices in the countrysides, the land ought to belong to the one who works it. . ."

Little by little, he became more involved in politics and finally became a member of MIR.[2] He was a member of the central committee of MIR. He took a political path similar to that of my oldest son. They arrested my oldest several times. They tortured him, and while he was a prisoner they had him in front of a firing squad on two occasions, but he was saved. He was imprisoned a total of three years, along with thirteen members of the central committee. Today he is alive and free. There isn't anyone else alive from that group now. They couldn't prove him guilty of a crime. At first, they

accused him of being involved with an "illicit society" and other charges related to his participation with protest mural paintings. The persecution, detentions, and torture were too much, and he finally sought asylum in the Costa Rican embassy. From Costa Rica he traveled to Switzerland, where he has lived ever since. Even now in 1994, after the rebirth of democracy in my country, my son, who wasn't found guilty of anything, can't return to Chile. I tried taking all the legal steps so that he could return, but the authorities told me the indictments were secret, and only he can arrange things through the Chilean embassy in Switzerland. The problem is if the rulings aren't accepted in Chile — if all the earlier charges haven't been resolved before he returns--they can make him serve a new prison sentence here.

The detention of my son Pizarro was different. The policemen went to look for him at the house on Godoy Street. The policemen who detained him came from the Sixth Precinct. They shot him during the arrest and took him away without explaining the charges. From there the policemen turned him over to the DINA for interrogation. My son was held along with a Bolivian compañero who was also detained the same day. His parents worked at the embassy and every kind of legal proceeding was undertaken to find him. Even the Bolivian government intervened along with several international organizations, but they didn't get any results either and that young man is still a *desaparecido* today. All the men who participated with my younger son's group are now dead or disappeared. There are mothers here, in my own country, who tell me to leave the past behind.

Those things are easy to say but impossible to do. You can't forget the disappeared, and while political prisoners exist in the jails of Chile our fight will continue.

We here in Chile have been in contact with other groups that fight for human rights throughout the world, especially women's groups that have been organized in the crusade to find the *desaparecidos*. We've worked with the directors of the Mothers of the Plaza de Mayo in Argentina and we've learned a lot from that organization, and in return our experience has served to strengthen their cause. For example, many mothers in Argentina refused the government's money offered through the Final Point Law; they refuse to stop looking for their children. They set an example for us. They can't buy our sons, husbands, brothers, and fathers with their money. You can't put a price on human life. The goal of the Final Point is to purchase the painful silence the officials who need to hide the truth. You can't pay for these crimes with money. It isn't important who's guilty. It's an insult to be offered economic compensation for the *desaparecidos* instead of truth and justice. It wouldn't occur to anyone to offer money to the mother of one of Hitler's victims so that the atrocities of the Nazis and the innumerable massacres can be forgotten. No one could think that money would cleanse the brutalities of history — so why do they offer me money for the life of my son? Why don't they tell me where he is? What happened to him? Is he truly dead? How did they kill him? Who is responsible for his death?

The Final Point Law was the ultimate insult to my son's children. When he was arrested his compañera was

pregnant; they were to be married the following week. The girl never saw him again and a few months later she gave birth to twins. The babies and their mother quickly immigrated to Switzerland. Years later, the children returned to Chile to look for their father. It was terrible when they received the government's offer of money to forget the fate of their father, to stop asking for reasons for his disappearance, and to cease searching for those responsible. They stayed awhile in Chile, helping me in the tireless search for their father. When they left, they swore never to return to this country unless they get some sort of explanation for what happened to their father. The last time they visited they were 18 years old. While in Chile, they attended school and contacted agencies that could help them uncover the fate of their father. Their classmates used to ask them: "Why do you want to find the bones of the dead?" My grandsons didn't understand the insensitivity of the other young people. Some classmates told them that they had to forgive and forget. They said that many of them had fathers and relatives who had been imprisoned and tortured, but they had put that behind them, they had forgotten it, or at least they were trying to forgive. My grandsons responded: "If our father was imprisoned and tortured, but we now had him back with us, perhaps we could forget and begin to forgive. But the bitter reality is that we don't know where he is or what happened to him."

My experience as a mother and wife has been extremely sad: I've said goodbye to everyone I hold dear in my life. My son is still a *desaparecido*, and the other

members of my family live in exile in Switzerland, Panama, and Cuba, where I can never see them. The enormous grief of constant farewells and of never seeing them return is making me old. My children married while far away and I didn't attend their weddings; they had their children but I never saw them born; my husband had an operation and I wasn't at his side during his illness. This dictatorship has stolen everything from me. Even the simplest pleasures that come with being a wife, mother, grandmother, and friend. The dictatorship took it all. . . but I am ready to surrender everything so I can find out the truth about Pizarro's disappearance.

I managed to see my children, grandchildren, and husband in 1991. I traveled to Switzerland and found myself in a strange world where no one knew me. My grandchildren were born in 1973 and 1974 and were already adolescents, my daughters were grown women, and my husband had become an old man. We all felt the dictatorship had wronged us in the most brutal way you could hurt a family: it separated us and filled each of us with a pain that was intense, strange, and permanent. To them, I had disappeared along with a brother, a son. . . for me, they had also, in a way, disappeared with my son. The only difference was we knew where we were, although we couldn't speak to or see each other.

During that reunion, my children and husband spoke of how our family had developed its political ideals. We realized how poverty gave us the ideology and hope to seek social justice through political changes so that we could live in a society where everyone had the same opportunities, where we would all have the same rights.

My eight children lived on the minimum wage of my husband — I stayed at home to raise them. My children always had to choose between eating ice cream or being able to take the bus to school. At the end of the school year we always took the blank pages out of the notebooks so they could use them the following year. We didn't have a hole-punch so we made the perforations in the notebook pages with a hot nail. All of them shared gym shoes because we could only afford to buy two pairs each year. Some went to class with shoes that were too big or too small, the one in the middle was the lucky one. All my children experienced the suffering, the poverty of living in a working-class family. That sparked the desire, at an early age, to better the social and economic life of the worker through political changes while also teaching them to share bread with the hungry, clothing with the one who is cold, and their roof with the homeless. They learned that school gave them "instruction" and at home they received an "education." I accept all the responsibility of my children's political consciousness and their desire to help whomever needs it. I inculcated that into my children — for my husband and me, it was an integral part of what we call culture. I never thought those values, in which I still firmly believe, would cause them so much suffering. That's a pain I cannot ease. But if I had it to do all over, I would do the same again. Today the grief of losing them is slowly killing me, but I prefer this sadness to the kind that the mothers of the torturers are suffering, the ones that executed so many people, so many compañeros and brothers, in the name of political and social changes. My sleep is troubled by sorrow, but there

is peace in my soul because I followed the path shown me
by God and my conscience as a mother. History will
judge me, just as it will judge the mothers of the assassins.
I hope to God that both experiences will serve as a de-
mand for justice, so that something similar will never
occur again anywhere in the world. We must respect life!

Many of us have maintained our faith in God, but
other women have abandoned hope and faith. They
don't believe in God, that unjust God who has only
punished them and protected the guilty. As for me, I
have a greater faith in the justice of God now that I have
lost my faith in human justice. God didn't steal my son.
The soldiers snatched him from me in the name of an
ambitious man who does not recognize love, justice, and
basic human rights. Now, I feel I am an instrument, here
solely to help the suffering. I am here in this world to
give myself completely to mothers who are suffering what
I have suffered, to help all who seek the path to true
freedom.

I owe my life to my fellow *arpilleristas* who helped
in this eternal crusade, in the search for my son. Because
of all the insanity I've experienced--the protests in which
I've participated, the detentions, the beatings I've re-
ceived, the years of desperation, the anguish, the grief —
everything affected me so much that one day I had a brain
hemorrhage that left me in a coma. I was hospitalized for
a time, fighting for my life, unsure if living meant being
left disabled. My compañeras came to see me every day.
They fed me, they prayed for me, and they talked to me
so I would recall dates, places, and people. They brought
me back to life when I felt I wanted to die. While in the

178

coma, I had dreams or moments when I felt like I left this world and found myself with dead people, who seemed alive again. I clearly remember seeing our President Salvador Allende. I saw many who had disappeared or were executed under the military government. But the most intense thing I remember, and my compañeras say I described it out loud, was the encounter with my disappeared son. I saw him on a rocky mountain holding a Chilean flag. His sweet face came out of the flag's white star, he looked at me and then told me that I had to go, I couldn't stay with him, I had to go away, to go back because I had to keep living. So while having those dreams, uncertain of what was happening, sometimes recognizing faces from this world and from the next, I slowly began to recover and to keep my eyes open, to eat, to move my arms, to return to life. I don't know what saved me, but I'm sure the love and dedication of my compañeras in the Association played a vital part. They prayed constantly, they protected me, and kept me clinging to life through the tremendous devotion that grew from our collective pain. We had never met before, yet now we are sisters, inseparable. The pain has united us forever.

The women of the Association replaced my family, especially my sisters and brothers who abandoned me after the military coup. The coup separated family members who were on different sides of the political problem. I had brothers, brothers-in-law, and nephews who were policemen. They viewed my sons' participation in the leftist parties as a cancer that needed to be wiped out. It didn't matter that we were blood relatives. Like in the

times of Hitler, they listened to the voice of the dictator and they killed — they set aside justice and family love and embraced hatred, torture, execution, and death. One of my nephews was killed in military training by a machine gun that was supposedly empty. The hatred that divided our family was so intense that my brother accused one of my sons of having secretly loaded that machine gun as a revolutionary act. Later, after the military investigated, my son was proved innocent. The hatred extended through the entire family. For many years I didn't see anyone — the ones who could have helped me look for my son didn't even come near my house, not for a second. They all said that my sons deserved to be punished for having supported leftist parties. I was finally reunited with my brothers after my coma. My illness brought them back to me, because they realized how I had suffered for years and now I might die without ever seeing them again.

The sad and ironic thing about my relationship with my older brother is now, after so many years, he indirectly understands the pain of my son's disappearance. In 1986, ten years after the accidental death of his policeman son, he found out that the burial period had expired. When his son died, they buried him in a plot to which he had the rights for ten years. After that time, the authorities remove the bones and rebury them in a common grave with other bodies that are in the same situation. My brother, very upset, came to see me because he couldn't bear to think that those bones, what remained of his son's body, were to be buried in a strange place where he'd never be able to visit them again. He came to see me

and wept. He told me he was desperate because he couldn't accept the idea of a common grave but he didn't have the money to buy another plot. I listened to him silently. I knew that, deep down, I could never allow my brother to suffer what I am now suffering: not knowing where my son's body is. I also thought perhaps he was crying because, at that moment, he was thinking about my pain of not knowing how my son died or where his poor body is now. I believe we both were wondering if my son's bones were buried in a common grave. Maybe he was among the hundreds of victims in the concentration camps that were built in the extreme north and south of our beloved Chile. When he expressed how he now understood my pain, his words were unnecessary, his tears said everything to me. I embraced him and promised that, somehow, I would get the money to give his son a new grave. . . his son, who was one of those guilty of the detention, torture and disappearance of my son. I spent days putting together the money and when I gave it to him I said, "Take it, brother. When you bury your son, imagine you are burying the remains of my son whom I cannot bury."

I am indebted to many people for all they have done for me and my family. Many people welcomed my exiled children. In return, I have opened the doors of my house for all who seek refuge for whatever reason. People from other countries come and stay until they can support themselves or find a place to live, and it's the same thing with people who come from other regions of Chile, here they will always find food and shelter. I learned this from my children who were always willing to help in any

way they could — above all my *desaparecido*, he always put the needs of others before his own. Even when my boys were very young, they would take off their own sweater or coat whenever someone needed it at school.

There has been a very profound change in me. Religion has affirmed my life, but the feeling of love for my country, the intense patriotism that I always had, has been slowly dying. I don't display the flag in my house. The next time I unfurl the flag — with its blue of a clear sky, the white of the mountains, and the red of Araucanian blood (like the popular song says) — will be the day when my loved ones return from exile, the day we are all free and can walk the streets of Chile without fear of political persecution, when there are no political prisoners in my country, that day when there is justice for political crimes committed in the name of the most brutal of dictatorships.

My life has changed forever, like the lives of all the women who have lived so many years under this dictatorship. All of us have had different experiences with different results. Some have died of cancer, others are almost crazy and take tranquilizers to stay sane, others are filled with a rage and hatred they can't control. All have reasons to feel what they feel, they have the individual right to change their lives, to live or die for our personal and collective cause. For me the change is a little different. Now that I feel I've lost everything, I don't feel hatred. I feel sadness for the tremendous injury that was done to my country, to the young people, the old people, the mothers, fathers, and children. I am terribly saddened by this wound to my native land that will never heal.

Also, I'll never be able to smile again nor experience the joy of life's simple pleasures. I don't have any happy memories — it seems the pain of these last years has erased my past with my tears and helpless cries that come during sleepless nights when I wonder where my son is. My desperation has brought me closer to God. I don't have room in my heart for hatred, and I can't accept hatred because that would be approving of what they did to our country in the name of hatred. Hate destroyed us. In order to be able to lift ourselves up again we have to have faith and hope, we have to forgive. I have to confess, that forgiveness is the most difficult thing I face right now. I feel the need to forgive in order to die in peace, but I don't know what happened to my son, I don't know where my son is, I don't even know if my son is alive or dead. . . after what I've been through, for all these reasons I don't know how or even whom to forgive. I want someone to deliver the guilty ones to me, and then I will begin to forgive. Because I truly need to forgive to be at peace and to follow in the footsteps of my son. . .

In 1992 I dedicated some words of homage to my son in a little book that was published. Here they are for people to read:

In this country we were free to speak, but the laws of truth and justice have been broken. Can our people ever cherish justice and truth? Did our country need the wound that is this experience — the deaths, tor tures, and disappearances? Faced with these questions,

we pray to God, the Father for our loved ones, asking
that the detained and disappeared may yet be found.

AFTERWORD

While we read the words of these women, we hear their voices tell of a dark episode in Chilean history; theirs are the voices that represent the many other protests which have been silenced by death, torture, and disappearance. Indeed, the eight women in this book are but a minimal representation of the numerous histories that have not been told. Nonetheless, those histories live on in the minds of all who have suffered, directly or indirectly, the effects of sixteen years of military dictatorship in Chile.

After I complied these testimonies, the reforms initiated by the second democratic government under President Eduardo Frei had begun to show positive results. However, the only request of the families of the detained and disappeared has yet to be met. Their bereaved cries constantly ask: Where are they? But the question is continually met by an eternal silence. As yet, no one knows what happened to the sons, husbands, fathers, and brothers of the women who appear in this book. Nor have those guilty been found or punished.

Gradually, the *arpilleristas* are discontinuing their artistic creation and the *arpillera* of denouncement is losing its *raison d'être*. Victoria Morales, president of the Association of the Families of the Detained-Disappeared, writes me often; through her letters, I see that the hope of discovering the fate of her brother is fading. But there still shines in her words the interminable desire to continue fighting so people will never, never forget what happened in Chile in 1973. Gala Torres stopped making *arpilleras*, ceased playing guitar and singing, and is battling cancer

without knowing the fate of her brother. Victoria Díaz followed her father's footsteps into the political arena. She spends most of her time organizing meetings, traveling to different parts of the world to attend conferences about human rights, and yet continues the relentless search for her father. Doris Menacotti has not given in to the pleas of her family who want her to leave Chile and live with her husband and her other children (and grandchildren!) in Switzerland. She has decided to remain indefinitely in her country seeking an answer for the disappearance of her son. The rest of the women continue participating in group activities: they sing and dance the *cueca sola*, and gather to daily reaffirm the interminable strength to keep searching--although it might be only for the remains, for the body of their beloved *desaparecidos*. So many years hoping, some day, to find them, if only to finally give them and themselves eternal rest.

As the collector of these heartbreaking histories and as eye-witness to the military coup on September 11, 1973, I entreat the readers of these pages that they never forget that . . .

> No, no they are not numbers
> they are not numbers
> they are names.[1]

— Emma Sepúlveda

[1] I wrote this brief poem in 1978 after one of my meetings with the *arpilleristas* at the National Vicariate. It appears in my book *Tiempo cómplice del tiempo*, published in Spain by the Torremozas Collection.

SELECTED BIBLIOGRAPHY

Agosín, Marjorie. *Scraps of Life: The Chilean Arpilleras,* Trenton, New Jersey: Red Sea Press, 1987.

Arzipe, Lourdes. "Forward: Demorcracy for a Small Two-Gender Planet." In Elizabeth Jelin (ed.), *Women and Social Change in Latin America.* London: Zed Books.

Bousquet, Jean Pierre. *Las Locas de la Plaza de Mayo,* Buenos Aires: El Cid, 1982.

Brett, Guy. *Through Our Eyes: Popular Art and Modern History,* London: New Society Publishers.

Bunster, Ximena. "Watch out for the little Nazi man that all of us have inside: The Mobilization and Demobilization of Women in Militarized Chile," in *Women's Studies International Forum,* 11(5). 1988.

Celedón, María Angélica y Opazo Luz María, *Volver a empezar,* Santiago, Chile: Pehuén, 1987.

Chaney, Elsa M. "The Mobilization of Women in Allende's Chile." In Jane Jacquette (ed.), *Women in Politics.* New York: Wiley and Sons, 1974.

Chavkin, Samuel. *Storm Over Chile: The Junta Under Siege.* Chicago: Lawrence Hill Books, 1989.

Chuchryk, Patricia. "Feminist Anti-Authoritarian Politics: The Role of Women's Organization in the Chilean Transition to Democracy." In Jane Jacquette (ed.), *The Women's Movement in Latin America.* Boston: Unwin Hyman, 1989.

_____. "Subversive Mothers: The Women's Opposition to the Military Regime in Chile." In Sue Ellen Chalton, Jane Everett and Kathleen Staudt (eds.), *Women, the State, and Development.* New York: The University of New York Press, 1989.

Concha, Jaime. "Testimonio de la lucha antifacista," *Araucaria,* Number 4, 1987.

Délano, Poli. *En este lugar sagrado,* México: Grijaldo, 1977.

Dorfman, Ariel. "The Autumn of a Dictator." In *Los Angeles Times*, May 13, 1990.

Dreifus, Claudia. "Chile's Challenge," in *Mother Jones*, (September-October), 1990.

Henfrey, Colin and Bernardo Sorj. *Chilean Voices*. New York: Humanities Press, 1977.

Kirkwood, Julieta. "Women and Politics in Chile," in *International Social Science Journal*, 35, 1983.

_____. *Ser política en Chile*. Santiago, Chile: FLACSO, 1990.

LaDuke, Betty. *Compañeras, Women, Art, & Social Change in Latin America*. San Francisco, CA: City Lights Press, 1985.

Mattelart, Michele. "Chile: The Feminine Version of the Coup D'Etat," in June Nash and Helen Icken Safa (eds.), *Sex and Class in Latin America*. Massachusetts: J.F. Bergin Publishers, 1991.

Orgambide, Pedro, *Cantares de las Madres de la Plaza de Mayo*, México: Editorial Tierra del Fuego, 1983.

Politzer, Patricia. *Fear in Chile: Lives Under Pinochet*. New York: Pantheon Books, 1989.

Rodriguez, Mario. "La organización de la cultura de Chile," *Mensaje*, Santiago, Chile: Number 275, 1978.

Sanders, Thomas. "Catholicism and Democracy: The Chilean Case," in *Thought*, (September) 1988.

Schneider, Cathy. "Mobilization at the Grassroots: Shantytowns and Resistance in Authoritarian Chile," in *Latin American Perspectives*, Number 18, 1986.

Schwartz, Cathy. "Chile: The Cost of Failure," in *Race & Class*, Winter 1987.

Valenzuela, María Elena. "The Evolving Roles of Women Military Rule," in Paul Drake and Ivan Jaksic (eds.), *The Struggle for Democracy in Chile*, Lincoln: University of Nebraska Press, 1991.

Vidal, Hernán. *El movimiento contra la tortura Sebastián Acevedo*, Ideologies and Literature, Minneapolis,

Minnesota, 1986.

_____. *Dar la vida por la vida: La agrupación chilena de familiares de detenidos desaparecidos*, Minneapolis: Institute for the Study of Ideologies and Literature, 1982.

Yáñez, Berrios, Blanca & Omar Williams López. "Cultural Action for Liberation in Chile," in Philip McManus and Gerald Schlabach (eds.), *Relentless Persistence*. Philadelphia: New Society Publishers, 1991.